BRITAIN'S HERITAGE

Stained Glass

Aidan McRae Thomson

Acknowledgments

I am deeply indebted to the following for their assistance with this project, particularly my sister Elspeth Thomson for driving me to several locations, along with Andrew Loutit, Phil Draper, Colin Underhill and Martin Beek for similar shared photographic expeditions. Thanks also to Roger Rosewell for his inspirational earlier volume on the same subject, Martin Crampin for his informative website and to Steven Cartwright and Clare Barclay for allowing photos of themselves at work to appear.

While the photos in this book are nearly all my own, I am most grateful to all who have allowed me permission to take them and reproduce them here. Special mention and a big thank you to all the churchwardens, vicars and clergy that have made this possible, particularly the Dean and Chapter of the Cathedrals of Birmingham, Canterbury, Coventry, Gloucester, Hereford, Lichfield, Lincoln, Norwich, Oxford, Wells and Worcester. Images are also reproduced courtesy of the Warden & Fellows of Magdalen College, the Warden & Fellows of Merton College, the Dean & Canons of Christ Church, the Master & Fellows of University College, Oxford, and the Provost & Scholars of King's College, Cambridge. I apologise for any inadvertent omission in being approached for permission or acknowledgement missing from here.

I dedicate this book to my father, Andrew McRae Thomson, 1935–2018.

Cover Image: Saints John, Peter, Paul and Luke from a window by Harry Clarke from 1929 at All Saints, Bedworth, Warwickshire.

First published 2018

Amberley Publishing
The Hill, Stroud
Gloucestershire, GL5 4EP

www.amberley-books.com

Copyright © Aidan McRae Thomson, 2018

The right of Aidan McRae Thomson to be identified as the Author of this work has been asserted in accordance with the Copyrights, Designs and Patents Act 1988.

ISBN 978 1 4456 8324 9 (paperback)
ISBN 978 1 4456 8325 6 (ebook)

British Library Cataloguing in Publication Data. A catalogue record for this book is available from the British Library.

Printed in the UK.

Contents

1
Introduction

What exactly do we understand by the term 'stained glass'? A concept familiar to many but a process familiar to few, how has this ancient but obscure medium so captured the popular imagination over the ages? By combining light with colour, making the divine seem tangible, stained glass has been almost exclusively an ecclesiastical art form through most of its history. No other medium relies on light so literally, transforming it to colour as if by magic.

The term generally denotes leaded glazing using coloured glass, lead having served as the connecting matrix for most of its history, though technical innovations in the later twentieth century permit us to broaden the term to include windows bonded with concrete or resin, or imagery screen-printed on glass sheets. However architectural glass continues to evolve, any creation involving glass, light and colour will likely still fit the same term. However, as this broader approach is a relatively new phenomenon our main focus will be on the traditional leaded variety.

Lead was for many centuries the only means of connecting glass in window construction, coloured or otherwise. Even the most basic windows required it before glass manufacturers

Below left: Coloured light emanating from walls of stained glass designed by John Chrestien at the modern Church of St Thomas More, Sheldon, Birmingham.
Below right: Splashes of divine light as blue and gold from the Millennium window by Roger Sargeant filter across and enliven the stonework at St Michael, Claverdon, Warwickshire.

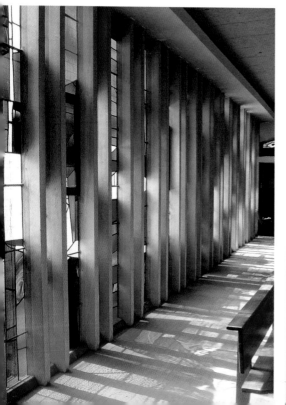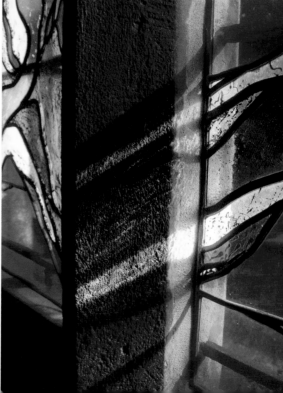

could produce the sheet sizes we take for granted today. Until the advent of mechanical glass processing in the later nineteenth century all glass was hand-blown, and while there was a marked improvement in the production of larger pane sizes by the eighteenth century, glass was still made either from cylinders (elongated bubbles of glass cut and flattened) or spun discs (known as 'crown' glass). It was rarely possible (or desirable) to fill a single opening with a single piece of glass, thus separate pieces needed a binding agent and malleable lead strips (shaped like an 'H' in section, allowing a piece of glass to be slotted in on either side) delivered the best means of overcoming this problem: soft enough to be shaped by hand however intricately the glass was cut, and strong enough to stand firm against the elements for a century or so before requiring renewal.

Even simple domestic plain-glazing was expensive and beyond the means of most in the Middle Ages; only the wealthiest could afford leaded-glazing in any form, but while most castles and palaces would have likely been provided with it, very little medieval secular glass survives. The greatest recipient was naturally the Church, which not only had the financial means to achieve large-scale glazing but also attracted the devotion of wealthy donors for whom the gift of funding to initiate a new stained glass window was an act of piety in itself (to the point that medieval donors were usually depicted in an attitude of prayer somewhere in the window itself). Churches also offered so much more in terms of scope: creative possibilities beyond the merely functional where imagery not only enriched the environment where the act of worship took place but also served to help educate and inform a mostly illiterate congregation, communicating the Christian message through pictures in glass, illuminated images to illuminate the onlooker. The unique quality of the medium, glass holding light and transforming it with colour, seemed to be a metaphor for the Divine itself, designs animated and changing through the day with fluctuating light as if touched by the light of God himself.

We should not be surprised therefore that the greatest body of work in stained glass is to be found in churches and cathedrals across the land as the Church continued to be the primary recipient of work on a massive scale, and although our medieval heritage has been so thoroughly decimated by the twin calamities of the Reformation and the Civil War a century later, enough remains at select locations to suggest what we have lost and how styles and tastes evolved over the centuries from the Romanesque period through the Gothic and on to the Renaissance.

What's more, our heritage was enriched further and in new ways in the following centuries, awaking from the long winter of

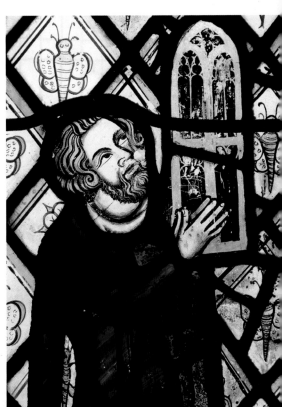

A fourteenth-century donor offers the window he has funded and is depicted in, an example of medieval pride in piety, portrayed in the act of giving. St Denys, York.

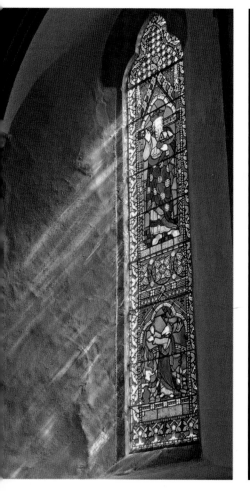
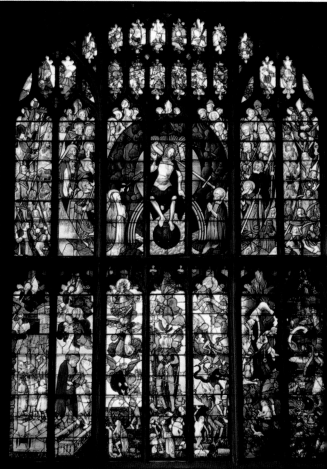

Above left:Victorian window from around 1854 by Frederick Preedy, casting coloured projections on a bright day at St Lawrence's, Weston-sub-Edge, Gloucestershire.
Above right:The west window of St Mary's Church, Fairford, Gloucestershire, installed around 1510 and depicting the Last Judgement (upper half restored following the original design). No other parish church retains its entire original glazing, thus Fairford provides a tantalising window on the past.

the Post-Reformation climate (with a few isolated but notable flowerings of enamel-painted glass in the seventeenth and eighteenth centuries) to the explosion of stained glass production in the nineteenth century, so huge that it makes up the vast majority of our entire heritage in glass to this day (for good and for bad). While the Victorian period attempted to turn the clock back and retrieve the lost medieval past, it failed to evoke it and mass-produced windows were in danger of bringing the art into disrepute. At the end of the nineteenth century there was a reaction against this, which gave us the Pre-Raphaelites and the Arts & Crafts tradition, both of which bequeathed some of the most beautiful stained glass ever seen.

The twentieth century has seen the most radical departure from the pictorial tradition that dominated windows for centuries before. Artists were liberated from the constraints

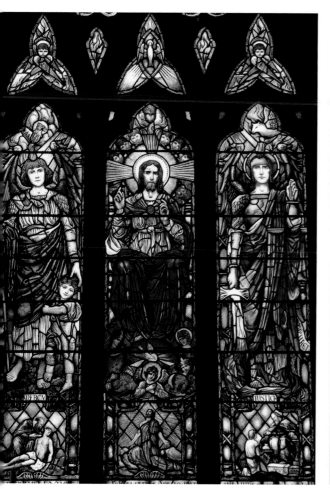

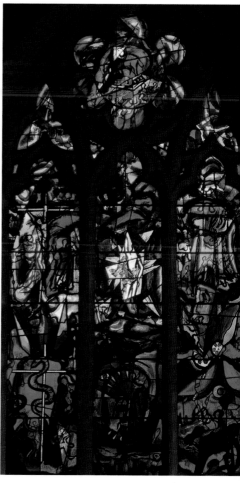

Above left: Christ in Majesty flanked by Archangels Raphael and Michael, a delicately drawn and coloured example of Arts & Crafts design by Arild Rosenkrantz, installed in 1918, Holy Trinity, Churchover, Warwickshire.

Above right: A vibrant exercise in bold modern expressionism by Patrick Reyntiens dating from 1964, St Andrew's, Scole, Norfolk.

of historical iconography and in many cases given free rein to express themselves in pure colour alone, harnessing the properties of the medium with stunning results. In form many of these works are shockingly different, but in technique they are remarkably similar as the craft itself remains essentially the same. It is important to have a greater understanding of this making process before going on to more thoroughly explore the diverse forms the art of stained glass has taken through the centuries.

2

The Making Process

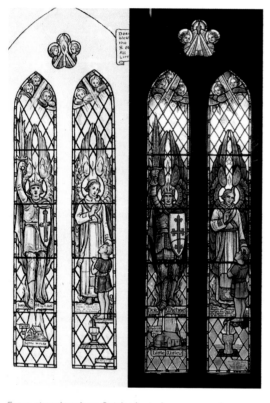

From tiny sketch to finished window: a rare chance to compare start and finish in Albert Lemmon's 1953 west window at St Michael, Little Witley, Worcestershire.

The technique of stained glass has remained largely unchanged over the centuries. After all, if something isn't broken, why fix it? The medieval process is described in great detail in the treatise of Theophilus ('On Divers Arts'), which was written in the early twelfth century, and, while modern tools have simplified the process, the overall treatment of glass and the respective stages it must undergo to form a leaded window are still clearly recognisable in contemporary craft. It is, however, a lengthy process: it has been said that there are more separate stages involved in making stained glass than in any other artistic medium.

As someone who works in the medium, I am constantly reminded how many misconceptions people have about stained glass and how it is made, many assuming the colours are literally painted on or 'stained', and while this is a long way from the truth they can be forgiven for making such assumptions when the name itself is so misleading, since very little glass is actually 'stained'.

Did you know?

The term 'stained glass' is actually a misnomer, as glass wasn't technically 'stained' until the discovery of silver nitrate in the first half of the fourteenth century, which allowed a yellow or amber stain to appear where applied and washed off after firing. This enabled colour change within a single piece of glass (best used on white or 'clear' glass) without having to resort to cutting a separate piece joined by lead, allowing flexibility of design. However this process was used for yellow or 'golden' accents only, so it is extremely rare to find an entire window that is literally 'stained' all over.

The recent advent of 'stick-on lead' for the domestic market, where a veneer of coloured plastic and a covering strip of lead adhesive are used as a cheap alternative for mass production, has reinforced the idea of 'coloured glass' as something applied to a single sheet window (a myth perpetuated by Hollywood movies whenever someone crashes through a coloured window!). The genuine article is entirely different, closer to the art of the mosaicist than the contemporary double-glazier!

Preparation

The starting point is of course the drawing board, and in designing for churches there are many factors to consider: there is the shape of the window itself, which may be a single aperture or one divided by mullions with complicated Gothic tracery in the head of the arch, which needs to be complemented in some form by the designer. The window may be an important light source so the client may urge restraint from anything too boldly coloured or detailed, and they will often have a specific subject or imagery in mind; every artist craves free rein, but this cannot be taken for granted when a donor may desire some input in return for the funding, or an incumbent may feel a specific devotional need for this part of their church. A stained glass window differs from other artworks in other media in that it will become a fixed and immovable part of the architecture itself, permanently altering the interior space, unlike paintings and sculptures, which are largely autonomous and may therefore be moved more easily to another location if desired.

Each stained glass window starts life as a simple sketch (often a watercolour impression to suggest luminosity) that must win the client's approval before anything can be done on a large scale. This sketch serves to communicate a basic vision of what the artist intends to create in glass, and in medieval practice was known as a 'vidimus' (meaning 'I have seen'). Once approval is secured (the all-important 'green light', which in the case of church windows may require further approval from a diocesan advisory committee before work can begin) the design can then be developed further as a full-scale drawing. Dimensions

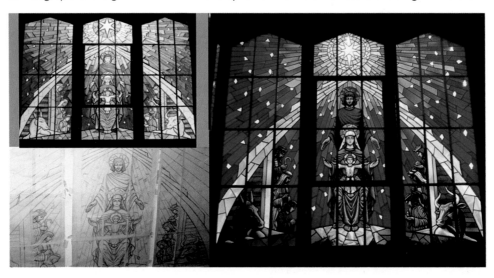

Once the initial concept is approved by the client, it can be translated into a full size cartoon and then into glass. This is a Nativity window by Aidan McRae Thomson, installed in 2011 at Christ the King, Kingstanding, Birmingham.

of the aperture should be taken prior to submitting the initial sketch in order to keep it in proportion with the intended opening, but when making the full-scale drawing (or 'cartoon') the accuracy of these measurements will be imperative in order for the resulting window to fit; more complex shapes (an arched apex or tracery lights) will require templates to be taken to ensure accuracy. Only then, with the dimensions securely set, can the designer execute the cartoon (traditionally finished in ink and normally kept monochrome).

The cartoon in effect becomes the master copy, the details of what is to be painted and the form of the leadwork being worked out at this stage. To translate this full-scale design into a window, a 'cutline' must then be made from it, a tracing of all the lead-lines that will then serve as the guide for cutting the glass: when tracing the lines representing the leadwork, it is important to use a pen whose width is approximately that of the heart of a lead came, so that in cutting the glass the required space is left between each piece to insert a strip of lead (about 1.5 mm). In medieval practice the use of such large-scale drawings and tracings on paper would have been rare; the usual alternative was to white-wash a wooden board or table-top and set out the design on this (an original fourteenth-century example survives in Girona, Spain, which shows evidence of at least two designs being made upon it, the earlier one simply being painted out so that the process could be repeated). Contemporary practice in mainland Europe differs from that in the UK at this point as the cutline is itself cut to pieces (using double-bladed scissors to ensure the required space for lead between pieces), thus providing every single piece of glass with its own individual template.

The Glass

With the cutline duly prepared, selecting glass can at last begin. The artist or studio should have a reasonable supply of stock sheets of the material, but will normally have to specially purchase specific colours for a given project from a glass supplier, and tracking down the desired colours can be a difficult task depending on available stock.

Each colour change normally requires a respective change of glass used, since the colour is already integral to the glass when it is blown, the result of the glass-blower adding various metallic oxides to the glass in the melting pot (giving rise to the traditional name of coloured glass as 'pot metal' for this reason). The oxides added to molten glass to colour it include cobalt for blue, cadmium or lead for yellow, copper for red and green, and even gold for pink (naturally one of the more expensive colours!). The molten glass is then gathered by the glass-blower and blown into a bubble, which is gradually elongated by movement until it resembles a hollow cylinder

Careful selection of glass is imperative to the window's success, and each colour will require the purchase of a separate sheet. Fortunately a wide choice is available, with Pearson's in Liverpool currently Britain's largest stockist.

Cut glass ready for painting for a new window designed and being assembled by Bettina Koppermann at the Canterbury Cathedral Stained Glass Studio.

with domed ends. Once the glass has sufficiently cooled the rounded ends are cut away, leaving a cylinder, which is then cut along one side in order for it to flatten out completely when reheated in the annealing chamber, thus creating a flat sheet of coloured glass. Cylinder or 'muff' glass has been the normal production method of coloured hand-made glass for centuries. Often bubbles will be trapped within the glass during the process, such 'imperfections' adding significantly to the aesthetic appeal of hand-made glass.

The original colour sketch provides a guide for selecting the different coloured sheets of glass required. Once a sheet has been chosen, it is laid over the cutline (the lines of which should be visible through the glass, darker colours requiring a light-box for this) and the surface is scored with a steel or tungsten-wheeled glass cutter. Straight edges and thinner glass can then usually be broken apart by hand along the scored line, but more complicated shapes and thicker glass will require tapping the glass (along the scored line in order to form a crack) or 'grozing' the glass with pliers, which involves slowly nibbling away the edges until the correct shape is achieved (with a more limited choice of tools, many medieval windows were mostly 'grozed' into shape, usually with a surprisingly high degree of precision. Cutting the glass at this time was a little more complex, involving drawing a red-hot pointed iron across the surface in order to control the break, often necessitating the application of water to shock the glass into splitting in the desired place). A simple leaded light after this stage will be ready for leading once all the glass is cut, but any attempt to realise something richer in glass, particularly a pictorial or figurative design, is only just beginning...

Painting on Glass

To a glass-painter, cutting the glass pieces provides the canvas; without painted detail, the window is simply a mosaic of coloured shapes. Paint not only defines the image, it crucially controls the light, softening the junction between contrasting hues to give a more harmonious effect. The pigment used is usually black or very dark brown, a fine powder paint (formed from metallic oxides and ground glass) which, when mixed with gum Arabic, will adhere and flow from the brush more easily (in the Middle Ages urine was often used for this purpose, a practice thankfully long since abandoned!).

Traditionally there are two main stages in painting glass, the first being to delineate the image by tracing it on to the glass with a fine brush from the cartoon laid underneath, adding all the solid black hard edges and line-work, outlining the details of faces, hands, folds of drapery and so forth. This stage is known as the 'trace-line' for the reason outlined above, copying all the linear parts of the drawing so the window bears a readable image. It will, however, appear somewhat flat and excessively bright if no more paintwork is added after this stage.

To augment the design with shading and modelling, a thinner application or wash of paint will be needed and can be applied over a much larger area and evened out with a broader paintbrush (preferably made with badger hair) after which highlights can be removed and areas brushed and stippled away (wet or dry) to create softer transitions in tone. This process adds considerable depth to figurative work, and a satisfying variety of tonal balance

Contrasting stages of glass painting: first the trace-line outlines the images' hard edges, followed here by washes of paint and stippling which give the images depth and modelling. This roundel was designed by Steven Cartwright for the Red Lion pub, Smethwick, West Midlands.

in more abstract designs. The process may be repeated with further washes applied before the painter is satisfied. Silver nitrate may also be added to create yellow/golden accents on select details.

Once glass is painted it must be fired in a kiln at around 650 degrees centigrade, at which point the glass begins to turn molten, enabling the paintwork to fuse with the surface and thus become more or less permanent (it is easiest to do this after each application of paint as it is quite vulnerable until fixed, though some more skilled painters execute both trace-line and shading washes in a single firing). Paintwork that is fired well will have a smooth, glossy finish when firing is complete and will thus last; less well-fired paint will retain the matt finish it had before firing, and in extreme cases may come off in time.

Did you know?

Many of the earlier Victorian windows in our churches have suffered badly from under-firing in the kiln, some being reduced to a collection of ghostly shapes with only faint traces of their former detail. The evidence suggests that kilns were at that time either firing too low for certain types of glass or were simply too difficult to regulate. The use of borax as a flux for the paintwork has also been blamed in some cases.

Leading Up

Once the sufficient amount of paint has been applied and kiln-fired, the more mechanical process of leading can finally begin. The cutline is again laid out on the bench and just as it served as the guide for the glass-cutting, so it will now also serve for the leadwork. With wooden batons securely fixed to define straight outer edges, the panel is slowly assembled like a jigsaw with a strip of lead between each piece. Lead came is designed as an 'H' section to hold and cover the edges of the glass on either side, with different widths available (thickest for the outer edges, thinnest for particularly delicate forms, but entirely flexible since lead itself becomes a graphic element of the window).

Lead is cut using a sharpened square-ended lead-knife. Once the lead matrix and glass pieces are fully built upon the cutline, the joints are soldered together using a tallow flux and a gas or electric soldering iron. Once this has been achieved the panel must then be carefully

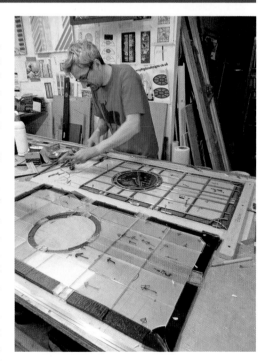

Leading up in the studio. It is critical at this stage to keep every piece in its correct place in order for the window to fit its new home. Photo courtesy of Steven Cartwright Glass Designs, Bromsgrove.

turned over and the process repeated on the other side before being structurally viable. Even after soldering both sides, the panel will feel weak and the glass within it may rattle when moving the panel.

The final act in the workshop is the waterproofing or 'cementing', in which leaded-light cement (usually linseed oil putty thinned with white spirit and blackened with a colouring agent) is thoroughly brushed into the leadwork, sealing it from water ingress and giving the leadwork a darker and more satisfying finish. It is a messy process (the least favourite of many workers in the medium) that normally requires a drying agent to absorb moisture before an equally thorough cleaning and removal of the excess putty, but it is a vital stage that will render the panel weatherproof and more rigid in preparation for installation.

The cutline is the essential guide to leading up a window correctly; the glazier must ensure the leads follow the lines on the drawing precisely. Photo courtesy of Norgrove Studios.

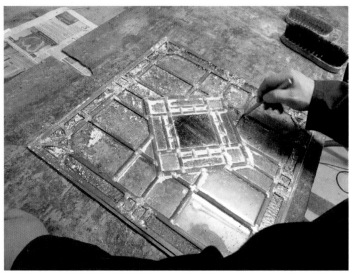

Cementing the panel after leading it together ensures it will remain weatherproof once installed. Linseed oil putty is brushed into the gaps between lead and glass, sealing it against the elements. Photo courtesy of Steven Cartwright Glass Designs, Bromsgrove.

Installation

Only after all these processes are performed can a stained glass window be ready for installation, and this in itself requires further thought in the workshop, since most windows will need supporting metalwork in the form of metal bars or 'ferramenta' that will sit against and across the window at joints and regular intervals to transfer the weight of the lead into the wall or frame once installed (copper-wire ties need to be attached to the panel prior to installation to be secured to these bars once in position). Without these, the considerable weight of the lead on larger panels would cause them to distort over time (discernible at many churches where windows appear to be bowing outwards, a symptom of insufficient use of load-bearing bars, though often not as serious an issue as it might look so long as it remains anchored).

Every job is different, but the same rules apply when fitting the glass: a wooden-framed window dictates fixing the glass into a rebate with glazier's putty, while a traditional stone-mullioned window (such as one might find in an older church) requires inserting the panels into a groove in the stonework around the aperture and then pointing the edges with a lime mortar. This work is especially complex in the case of elaborately shaped panels such as traceries or rose windows and often involves working at great heights from a scaffold.

Only after this long and drawn-out journey does the window finally take the form its designer intended. Usually several months or more may have elapsed by this time, and it is always a huge moment of relief for the maker once the window has been fitted in place and approved by the client.

Below left: Installation requires fixing of the panels into a 'glazing groove' cut into the stonework, with metal support bars usually on the inner face. Elaborate shapes can be a challenge, as in this rose window at St Nicholas, Radford Semele, Warwickshire.

Below right: Once the leaded glass panels are in place, the edges of the stonework are pointed with lime mortar. Clare Barclay here finishes her new window for Norgrove Studios at St Lawrence, Bidford on Avon, Warwickshire.

Other Techniques

There isn't the space here to discuss these in too much detail, but the latter half of the twentieth century saw two significant deviations from the traditional leaded technique of stained glass as outlined above.

The most popular alternative was the 'dalle de verre' ('slab of glass') technique, which was pioneered in France during the 1950s. This involved the use of thick, chunky glass made in cast blocks or slabs (over an inch thick) rather than the usual sheet. Too thick to be cut with a glass-cutter, glass was split into jagged chunks by breaking it over an anvil, then set into a matrix of poured concrete or resin (replacing lead, though a metal armature was usually concealed within as reinforcement). The type of thick glass used precluded any use of painted detail so dalle de verre windows are generally an exercise in pure bold and fragmented colour, which is intensified both by the thickness of the material and the multi-faceted edges (standing proud of the internal surface) that catch the light beautifully.

The medium, involving so much heavy concrete, wasn't suitable for use in historical settings and is mainly found in modern churches up to the late 1970s, since when its popularity has declined dramatically.

Glass appliqué was another method that appeared in the 1960s and strove for greater freedom still from the straightjacket of a lead (or concrete) matrix. The process involves bonding pieces of coloured glass to a clear backing-sheet using a strong clear glue or resin and resulted in some stunning expressions of modern creativity. Alas, it has had a limited shelf life, with many pieces simply not standing the test of time, particularly where expansion and contraction of the glass in extremes of temperature have caused it to detach or the bonding agent to fail. Major examples of the technique included the original glazing of the lanterns at Blackburn and Sheffield cathedrals, both of which were sadly consigned to history after becoming unsafe within two decades of their installation.

The lesson from history seems to be clear: the tried and tested methods can be relied on while new innovations run the risk of a much shorter lifespan, but given what flowerings of creativity new techniques have given us, we may yet hope that some refinement will yet keep these alternative processes viable.

Dalle de verre is characterised by thick chunky glass far too thick for leadwork; its broken facets are perfect for capturing the light. Glass by Hardman Studios at Sacred Heart, Ilkley, West Yorkshire.

3
Medieval Glass

Anglo-Saxon Glass

The story of stained glass in Britain begins in late seventh-century Northumbria, at the twin monasteries of Monkwearmouth and Jarrow, when Abbot Benedict Biscop sent for glaziers from France (a craft unknown in Britain) for the glazing of his new monastic church (also reputedly the first ecclesiastical building in the country to be built of stone). Remarkably, much glass from this period was found during excavations at the sites of both monasteries and some of it was fit to be re-leaded to form panels, some of more decorative, geometric patterns while more seemed to suggest the outlines of a figure. There is a degree of conjecture regarding the present arrangement of this glass, though the suggestion of an attempted figurative window even at this early date is intriguing. However, there is no evidence that any of this glass was painted, and at this early stage it is likely that many windows would have been simple coloured glass and lead arrangements. Fragments have also been found at other Anglo-Saxon sites, so the seed planted by a Northumbrian abbot around 679 AD seems to have gradually spread as church building across the country began to take on a more durable form.

When exactly glass painting was first introduced is impossible to say as almost nothing survives in Europe beyond mere excavated fragments until the eleventh century. The oldest known example of painted glass is the fragmentary head of Christ excavated at the site of Lorsch Abbey in Germany, believed to date to the ninth or tenth century, while in the same country can be seen the world's oldest complete windows at Augsburg Cathedral, which consist of five fully developed painted depictions of Old Testament prophets that have been dated as far back as c. 1065. In England, a roughly contemporary fragment of glass painted with an acanthus leaf design unearthed at Winchester may represent our earliest extant painted glass.

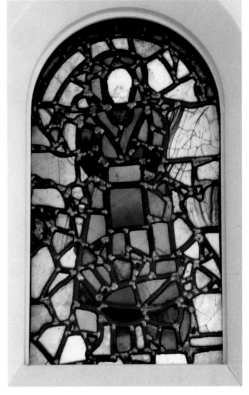

Anglo-Saxon glass from around 679, excavated at Bede's monastery in Jarrow and reassembled into a figure (with some conjecture). Now displayed at the Bede Museum, Jarrow Hall, Groundwork South Tyneside & Newcastle.

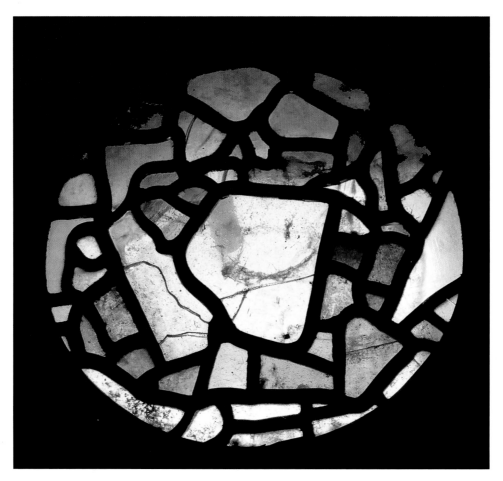

The oldest glass in a British church: excavated fragments of Anglo-Saxon glass from the Jarrow monastery, now releaded into this small roundel in St Paul's, Jarrow, South Tyneside & Newcastle, Tyne & Wear.

The Norman Period

In the years following 1066 Anglo-Saxon England was all but consigned to oblivion by the invading Normans, so it should come as no surprise that so little pre-conquest material remains. The new Norman masters initiated a massive building campaign, replacing our more humble Saxon churches with grand new edifices in the latest French style; huge new cathedrals and abbeys were constructed on a scale never before seen in England. Virtually every major ecclesiastical institution saw a new church built, far more imposing than anything that had gone before, and the cathedrals of Durham, Norwich, Ely and Peterborough remain as superlative testaments to this architectural revolution, being our least altered examples of monumental Romanesque.

The drive to rebuild churches naturally brought the need to glaze them, and glass was again ordered from France (as, most likely, were the glaziers). France and the Rhineland already had a long established tradition of glass-making, mastering the art of adding colour,

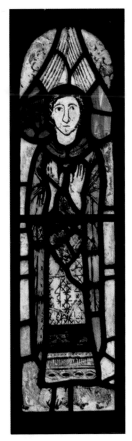

A Romanesque figure of an archangel from around 1100: a rare survival and the oldest complete window known in Britain, All Saints, Dalbury, Derbyshire.

particularly rich cobalt blues and ruby reds, which dominate the surviving windows of the period. Their success was such that throughout the medieval period and beyond, coloured glass was always imported from mainland Europe, which made it a costly material. Ultimately, glass would be produced at several locations across England, but only the plain, non-coloured variety.

Again, surviving examples of Romanesque glass in Britain are extremely scarce, and practically nothing survives from the eleventh century. The presumed earliest surviving complete window is the Archangel at Dalbury, Derbyshire, believed to date to the early decades of the twelfth century (an earlier date is possible). This figure has a simplicity of line and colouring reminiscent of early manuscript illustrations and, as the sole surviving window from before 1150, leaves us wondering what we have lost elsewhere. What we do know is that most windows would have been fairly small by medieval standards, since heavy and muscular Norman architecture admitted limited window size in proportion to the available wall-space, and all would have been single round-headed lights, uncluttered by mullions or tracery.

It is from the 1180s onwards that the evidence becomes plentiful, and most of this is to be found at our two greatest cathedrals, Canterbury and York. York Minster was glazed as far back as the late seventh century but the earliest remaining glass dates only to around 1180. The oldest of the panels shows a seated king from a Jesse Tree (a popular medieval visual device for representing the ancestry of Christ, tracing his descent from King David). Other panels include scenes from the lives of saints, all executed in rich glowing colours on a particularly vivid blue background. Their context, however, is lost and only isolated panels survive.

Canterbury, by contrast, offers our first opportunity to examine not only complete windows from the 1180s onwards but an entire scheme of them. The east end of Canterbury Cathedral suffered a devastating fire in 1174, necessitating a major rebuilding, which ushered in the latest architectural style from France, the first uses in England of the pointed Gothic arch.

Did you know?

The Gothic style was first introduced in England for the rebuilding of the choir at Canterbury Cathedral by William of Sens following the fire of 1174. However, Gothic had emerged as far back as the 1140s when Abbot Suger rebuilt the Abbey Church of St Denis near Paris, which is celebrated as the first use of fully developed Gothic, and the subsequent dramatic increase in the size of windows opened up immense new opportunities for the glazier.

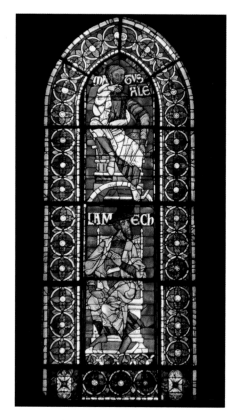
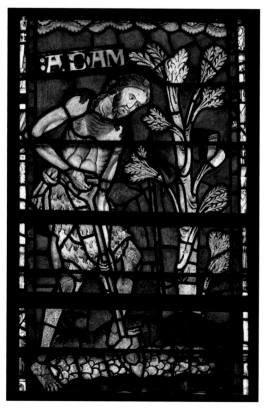

Above left: Two of the Ancestors of Christ, from around 1180, seen here as part of a sequence in their original configuration (displayed as part of a temporary exhibition in the choir clerestorey), Canterbury Cathedral, Kent.

Above right: Adam delving: the first figure in the Ancestors of Christ series and one of the best preserved examples of late Romanesque glass painting, from around 1180, now in the west window, Canterbury Cathedral, Kent.

The new glazing began with the upper windows (or 'clerestory') of the choir, for which a program was drawn up to depict Christ's genealogy with a pair of figures in each light, illustrating patriarchs all the way back to Adam and surrounded by rich ornamental borders.

The Ancestors of Christ at Canterbury constitute the greatest surviving scheme of Romanesque stained glass in the country (around half survive, most since reset elsewhere in the cathedral, their original positions taken by copies). The earliest figures are on a more monumental scale and bear comparison with Romanesque painting and sculpture here and abroad. The boldly linear figures stand proud against a rich blue ground which, with ruby, is the defining colour of Romanesque glass.

Transition to Gothic

Canterbury, however, is a transition of styles, constructed at the end of the Norman period with glazing spanning the years *c.* 1180 – *c.* 1220, mixing both late Romanesque and early Gothic. The glazing of the aisle windows below follows the same glowing palette with its figures against rich blue backgrounds; however, the format is quite different, with a multitude

of smaller scale figures grouped into square panels and medallions, all set within geometric patterns and enfolded by gorgeous stylised ornamental foliage around the vignettes and in the borders. The windows are larger than their Norman predecessors, though only vaguely pointed and still preceding the advent of window tracery; thus, the individual component panels are held in place by a complex system of ferramenta, a wrought iron framework into which the panels are held by pegs (a system abandoned in the following decades as the introduction of mullioned windows reduced the width of individual apertures and the need for such expanses of metalwork).

These windows are designed to be read as narrative, illustrating the Life of Christ while balancing it with Old Testament parallels, a recurrent theme throughout pre-Reformation iconography. They are more than just gloriously decorative, also serving a didactic role in communicating through imagery, imparting the Christian message at a time when most were illiterate, and a picture after all tells a thousand words.

Not all windows told Biblical stories; while York featured the lives of saints, Canterbury went further still. In 1170 Archbishop Thomas Becket had been martyred here: his shrine rapidly became a major place of pilgrimage, attracting revenue from pilgrims who came to the tomb for its reputed healing properties. Many pilgrims attributed miraculous

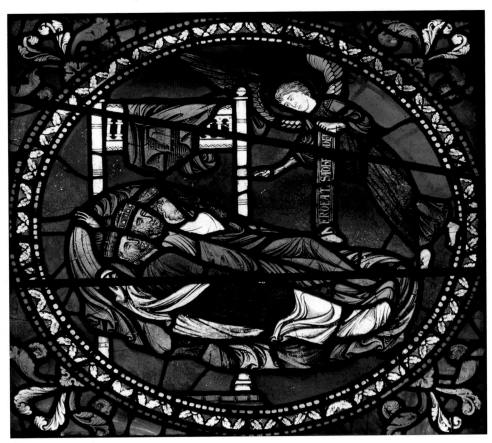

The three Magi warned by an Angel not to return to Herod. One of a sequence of Biblical narrative panels dated *c.* 1180–1200 in the north choir aisle, Canterbury Cathedral, Kent.

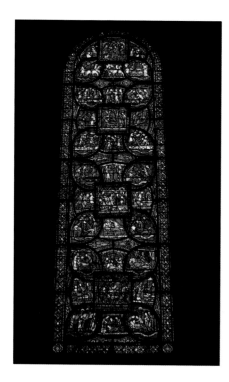

An example of the complexity of design and richness of effect possible when a sequence of narrative vignettes is desired. This is one of the 'Miracle Windows', from around 1220, at Canterbury Cathedral, Kent.

properties to the shrine, others invoking St Thomas Becket privately to the same end. The resulting individual stories of redemption made a fitting subject for windows surrounding the shrine, which were filled with medallions (set in delightfully complex patterns) recounting the legendary cures and miracles performed here, impressing the pilgrim with both their dazzling richness and the shrine's vaunted reputation. The figures are painted with vigour and designed for clarity; most of the detail is defined by the trace-line, with minimal use of shading. Their large, expressive eyes and the almost classically inspired folds of drapery still reflect the old Romanesque style, but with an overall delicacy that looks ahead to the Gothic.

Early English Gothic

With the bulk of our earliest glass now lost to us, it is tantalising to imagine a time when churches and cathedrals across the country might have been brimming with the intense reds and blues of Canterbury's glass, but the truth was not so simple. So much densely coloured glass was highly expensive, requiring import from Europe, and thus in large volumes beyond the means of most humble parishes. Additionally, by the 1200s the Gothic style had fully taken root and this new architectural revolution broadened the scope for glaziers by vastly increasing the sizes of windows for them to fill.

The first flowering of Gothic in the early thirteenth century is now known as 'Early English', for while the Gothic style itself was of French origin, it had rapidly evolved here into a more indigenous expression. Glassmaking, however, still betrayed French influence and more extensive survivals in France may offer a glimpse of what we have lost elsewhere. Lincoln Cathedral certainly possessed glazing of a similar type installed around 1220–30, characterised by a series of rich figurative medallions on a blue ground comparable to those at Canterbury. More complete, however, is the north rose window or 'Dean's Eye', a masterpiece of thirteenth-century tracery which still largely retains its rich original glazing depicting the Last Judgement.

Similar glass survives to a lesser degree at Salisbury, just enough to show that while some elements echoed Canterbury and Lincoln, a significant proportion was adorned with non-figurative patterned designs in mainly clear glass known as 'grisaille'. The economic benefits of using large areas of non-coloured glass (the only type natively manufactured throughout the medieval period) are easy to see, and many such windows would have been entirely decorative, adorned with painted leaves and vine with only a few very small accents of colour in select places.

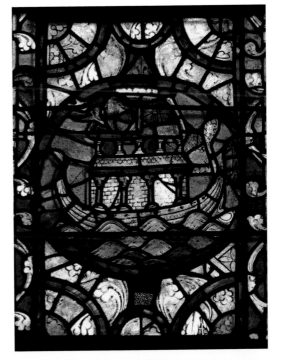

Right: Noah's Ark, one of a series of rich early thirteenth-century medallions at Lincoln subsequently reset in a later extension of the building, north choir aisle, Lincoln Cathedral.

Below: The 'Dean's Eye' rose window depicting the Last Judgement, c. 1220–35. Though substantially patched with compatible glass from elsewhere in the cathedral, the original vision largely survives, north transept, Lincoln Cathedral.

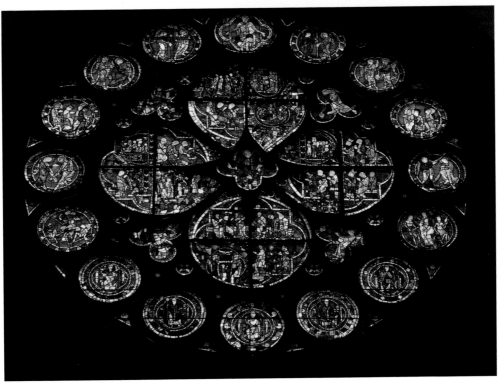

Did you know?

Grisaille glass also had theological impetus from the teachings of St Bernard of Clairvaux, who founded the Cistercian Order in 1134. He considered much pictorial decoration in churches to be a distraction from prayer and rejected it, inspiring a simpler form of adornment to be adopted thereafter in Cistercian monasteries.

Grisaille was often used on a vast scale, and while the great Cistercian abbey churches that once contained swathes of such glazing have long been lost, isolated examples remain to indicate what was once there. Perhaps the most common form of stained glass combined both approaches, with a figurative medallion or scene set amid ornamental stylised foliage in white, allowing a more frugal use of coloured glass without sacrificing the imagery which would serve either a devotional or didactic role.

Below left: An example of thirteenth-century grisaille glazing, somewhat restored but indicative of the non-figurative approach of much lost Cistercian glass of the period. Lady Chapel, Hereford Cathedral.

Below right: A decorative element set in grisaille formed a balance, in terms of admitting light, portraying a subject and acknowledging budget, a format widely used. Detail from a side window at Merton College Chapel, Oxford.

Decorated Gothic

Transition from single lancet openings to traceried windows posed new challenges for the glazier. Division by vertical stone mullions (and later horizontal transoms) gave internal support to a window, allowing ever increasing expansion of a window's outer dimensions, but as a result of this subdivision of the space, individual component lights became taller and narrower, restricting the amount of imagery that could be contained. An increasingly common solution was to depict individual standing figures beneath decorative canopies, imitating the effect of statuary within a niche. The tracery above, at the apex of the window,

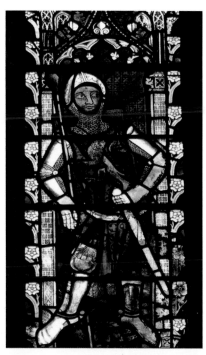

Right: A figure of Robert Fitzhamon set within a simulated niche, from around 1340, from the choir clerestorey, Tewkesbury Abbey, Gloucestershire.
Below: Tracery lights containing a wealth of detail, with scenes and images of saints alongside curious hybrid creatures, early fourteenth-century glass in the Lucy Chapel at Christ Church Cathedral, Oxford.

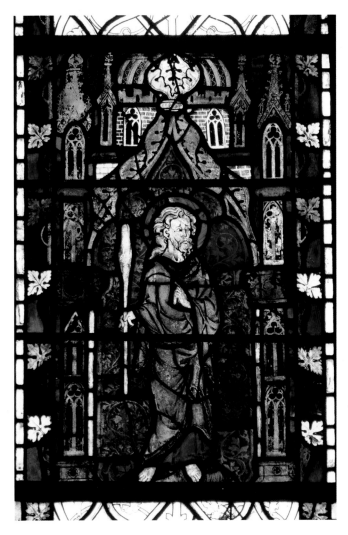

began to evolve into ever more complex designs and shapes (often filled with angels and fanciful beasts), all part of the taste for decorative flourishes of stonework that helped to give this phase of English Gothic the name 'Decorated'.

The two most complete surviving schemes from around the turn of the fourteenth century, Merton College Chapel in Oxford and the nave aisle windows at York, both use large areas of grisaille with a horizontal band (two at York, owing to the immense scale) of coloured elements across all three main lights. In each case the panel is designed like a tabernacle, the scene or figure contained within a canopy of fairly squat dimensions which rarely protruded into the plainer grisaille above. In the coming decades, however, the role of grisaille diminished and these canopies would become ever more prominent, often more dominant and decorative features than the saints they sheltered.

Some of the earlier examples of this type can be seen in the choir clerestory of Tewkesbury Abbey, where a full set of standing figures beneath canopies fills the windows. The architectural elements show attempts at perspective in a desire to give these simulated niches depth, while space beneath is given to display coats of arms. Heraldry plays a prominent role in fourteenth-century glass, and helps explain the shift away from more budget-conscious windows incorporating plain grisaille sections to full-blown stained glass displays filling the entire space. Private sponsorship was all the more attractive to the wealthy when their gift to the church not only aided their immortal soul but illustrated their pious generosity for all to see.

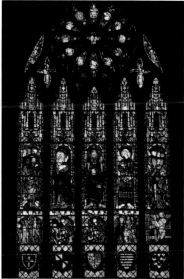

Above left: Canopies from around 1350, illustrating the decorative treatment often given to architectural elements, showing an attempt at perspective and populated by small figures. St Michael, Moccas, Herefordshire.

Above right: Christ and saints above scenes of resurrection and donors' arms, from around 1340, east window, Tewkesbury Abbey, Gloucestershire.

Did you know?

Henry de Mamesfield, Chancellor of Oxford University, donated the side windows at Merton College Chapel in around 1310, each containing a central saintly image flanked by kneeling donor figures, thus the donor appears in glass twice as often as any saint, no less than twenty-four times!

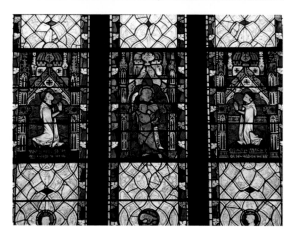

A 'band window' of grisaille with coloured glass reserved for the subject panels, here a saint flanked by kneeling images of the donor, Henry de Mamesfield, from around 1300–10, Merton College Chapel, Oxford.

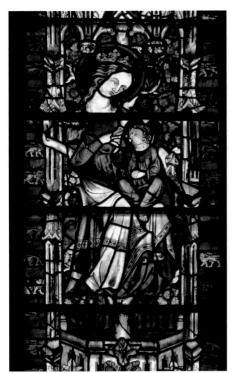

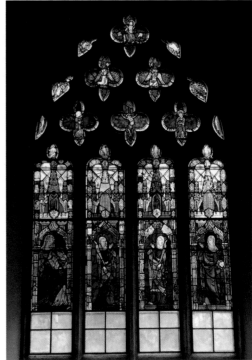

Above left: Virgin and Child, detail from the Tree of Jesse, a remarkably complete survival from around 1320–40, east window, Wells Cathedral, Somerset.

Above right: Window of around 1350 depicting female saints under canopies, while Christ's Crucifixion and subsequent enthronement occupy the traceries above. St Nicholas, Stanford on Avon, Northamptonshire.

The most noticeable change, however, as we pass into the fourteenth century is the difference in palette: blue, such a dominant colour in the preceding centuries, seems to be used more sparingly in favour of warmer hues with gold, ruby and olive or emerald greens. Wells Cathedral illustrates this colour scheme well in substantial surviving elements of the choir glazing. Other outstanding examples of glass of this period can be seen at Eaton Bishop (Herefordshire) and Stanford-on-Avon (Northants).

A crucial discovery was made around 1315 that had a huge impact on window design in the following centuries, namely silver nitrate or 'yellow stain', the only true stain in stained glass manufacture. This (toxic) orange powder was mixed with water and applied with a brush (usually to the outer face of the glass) on details such as hair, haloes and crowns and washed off following firing to leave a golden 'glow', for the first time enabling a change of colour without requiring a separate piece of glass. This gave much greater freedom and fluidity to the drawing, with the added budgetary benefit of enabling locally made white glass (with stained details) to play an increasingly large role as a major component of stained glass windows towards the later fourteenth century and beyond.

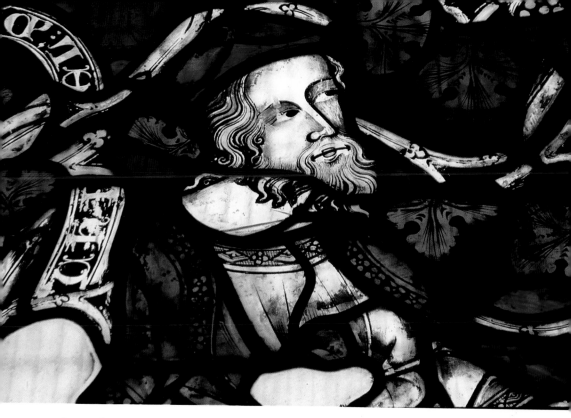

Figure of a prophet from around 1350 showing a distinctive facial treatment and use of silver stain to create yellow accents. Detail of the east window, Madley church, Herefordshire.

Perpendicular Gothic

In its final phase, English Gothic reached its apogee as a truly national flowering with the Perpendicular style, so called for the highly decorative grid-like forms of mouldings and mullions that became a major hallmark. The size of window aperture in relation to the actual wall space became so dramatic that in some instances the walls appear to be mostly glass, with the role of the masonry largely reduced to that of a stone cage or lantern. This naturally had budgetary ramifications and it is small wonder that the proportion of white or clear glass used in windows was growing ever larger.

The earliest surviving manifestation of the Perpendicular style is the remodelling of the

The largest continuous expanse of glazing in an English church, the east window of Gloucester Cathedral (c. 1335) fills the entire eastern wall, a pioneering example of the new heights attainable in Perpendicular Gothic architecture.

choir of Gloucester Cathedral, beginning in around 1335. The east window is one of the largest medieval windows in existence (an example of an almost entirely glazed wall) and still retains most of its original glass, an extensive display of saints and kings within simulated niches. The figure drawing isn't as progressive as the architecture, but the design utilises a curiously limited palette, with figures and tabernacle work painted purely on white glass with subtle elements of yellow stain, the only coloured glass being limited to alternating blue or red backgrounds (this minimal use of colouring seems to have been the exception rather than the rule in the mid-fourteenth century, although there remains figurative glass of the same period at Fledborough in Nottinghamshire that goes a step further, being executed entirely in monochrome).

From the late fourteenth century comes the first name recorded for a stained glass artist in England, Thomas Glazier of Oxford (active *c.* 1385–1427), who was responsible for extensive glazing schemes at New College, Oxford and Winchester College Chapel. In each case the format is of the familiar standing figures in niches type, but significantly the drawing is far more refined and shows awareness of Continental work, being less stylised and more naturalistic than what had gone before.

Later developments in design at the turn of the fifteenth century would largely maintain a reliance on large areas of painting and staining on white (though otherwise with a broader range of colours) and see a resurgence in purely narrative windows, with often vast areas of glazing divided into a series of roughly square compartments containing a scene within an

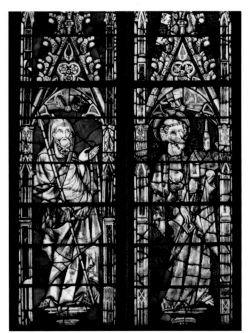

Above left: St Thomas and St Peter, from around 1335, part of a series of saints rendered in near monochrome with red and blue grounds the only major use of colour. Detail of the east window, Gloucester Cathedral.

Above right: The Acts of Mercy window at All Saints, North Street, York. A classic example of early fifteenth-century design, subdividing a window into narrative compartments (though not all are in situ).

Detail of a legend of the Palmer's Guild, featuring
King Edward the Confessor and a number of figures
exhibiting contemporary costume, from around
1450. St Lawrence, Ludlow, Shropshire.

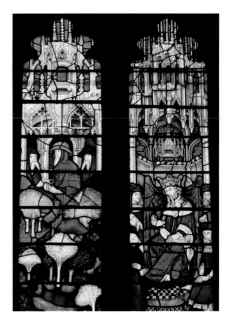

Detail of a legend of the Palmer's Guild, featuring King Edward the Confessor and a number of figures exhibiting contemporary costume, from around 1450. St Lawrence, Ludlow, Shropshire.

architectural frame. A greater sense of naturalism was combined with finer detail and painted line, while figures often consciously displayed contemporary attire (likely influenced by medieval mystery plays). Themes ranged from the purely Biblical, with Old and New Testament sequences (good examples survive at Great Malvern Priory), to largely apocryphal episodes from the lives of saints (particularly those of cultic significance where a shrine existed). Alternatively the theme might be doctrinal, representing the Seven Sacraments or Acts of Mercy.

The greatest of all such windows (both in scope and scale) is the east window of York Minster, a colossal undertaking commissioned in 1405 from John Thornton of Coventry (active *c.* 1400–33). Comprising some 117 pictorial panels across its vast nine lights, most are devoted to the theme of the Apocalypse with a shorter sequence from Genesis above. The immense height, of course, means that many of these subjects are difficult to read from the floor, with no concession made to distance beyond rich use of colour; clearly, depicting the complex narrative in full was a greater priority for this glass story-book to impart its serious message (warning of the end of days), and each element is meticulously finished, whether visible to man or only passing angels.

Did you know?

The Church of All Saints, North Street, in York, contains a remarkable narrative window on a similarly apocalyptic theme, but in place of the usual Biblical scripture the scenes uniquely follow the medieval poem known as the 'Prykke of Conscience' which describes the last fifteen days of the world, showing an almost secular take on the subject, indicating that inspiration could be derived as much from popular literature as scripture, provided their messages aligned.

John Thornton is the most famous of the known English medieval glass artists, and his style is distinctive, particularly his characteristic treatment of faces, which allows other windows in York and beyond to be associated with his style. Coventry was therefore an important centre for glass-painting during this period, along with York, Norwich, London and Oxford, with specific stylistic hallmarks often discernible in the output of each. Other named glaziers include Thomas Wodshawe and Richard Twygge, who were responsible for much of the glazing at Great Malvern Priory and were most likely based in the town.

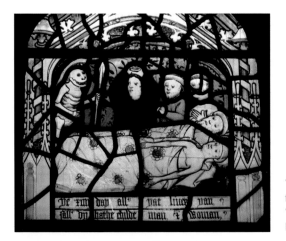

'Death comes to claim all mortals', a scene from the astonishing early fifteenth-century 'Prykke of Conscience' window at All Saints, North Street, York.

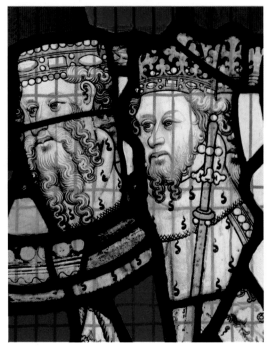

Early fifteenth-century painting exhibiting strong stylistic affinity with the work of John Thornton. Note the yellow smear on the second face, an accident caused by contamination of silver-stain from a previous firing in the same kiln, All Saints, North Street, York.

Another notable name is John Prudde, appointed 'King's Glazier' in 1440 and responsible for the sumptuous glass of the Beauchamp Chapel at St Mary's, Warwick. Clearly work of the highest quality, both in design and execution, the work reverses the trend for predominant painted white glass with a much richer array of colours (the result of forsaking the usual architectural elements in favour of richly patterned backgrounds, along with a wealthier donor!), with even tiny 'jewels' of colour inserted into details of costume (by drilling through the glass – a difficult procedure!). What survives at Warwick is merely a glimpse of how the complete scheme must have appeared, and the loss of Prudde's royal commissions elsewhere is clearly a grievous one.

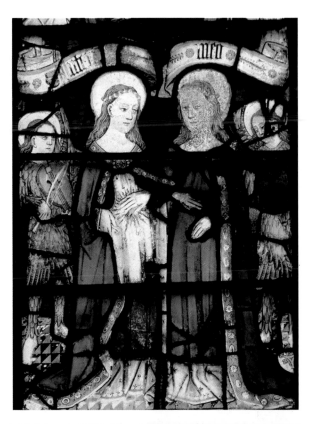

Right: The Visitation, a scene from the Magnificat Window, the work of Richard Twygge and Thomas Wodeshawe from around 1500. Great Malvern Priory, Worcestershire.

Below left: St Thomas Becket and St Alban, part of royal glazier John Prudde's exquisite glazing from 1440 in the east window of the Beauchamp Chapel, St Mary's, Warwick.

Below right: Feathered angels (likely inspired by costumed players in medieval mystery plays) hold sheets of medieval church music in the tracery lights of the Beauchamp Chapel, St Mary's, Warwick.

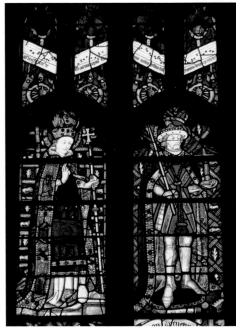

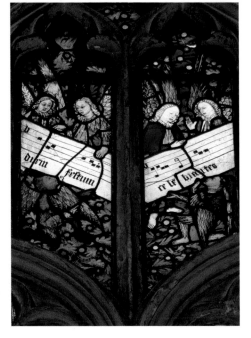

Late Gothic and Renaissance

By the end of the fifteenth century native artists were facing fresh competition from the Continent as English work was perceived to be some way behind developments abroad. A growing awareness of Northern Renaissance art provided a fertile ground for Flemish artists who settled in London from around 1500 onwards, and recognition of the advanced style quickly won them important commissions. This caused resentment among native glass painters, resulting in their London guild barring the newcomers from working in the City, but they circumvented this legal barrier by basing their workshops in Southwark, merely crossing the Thames to escape the City's limits. Ultimately the new skills and artistry the settlers brought won them royal patronage, with appointments for both Barnard Flower (d. 1517) and Galyon Hone (d. *c.* 1551) respectively as King's Glazier.

The earliest surviving major work of the Anglo-Flemish workshops is the glazing of the newly rebuilt St Mary's, Fairford (Gloucestershire), executed around 1500–15, likely under the supervision of Barnard Flower. This remarkably complete surviving scheme manages to be medieval in spirit yet early Renaissance in detail, with more naturalistic saints and prophets lining the aisle windows under their still Gothic canopies. The narrative windows, however, make a more radical departure, their subjects filling entire lights or windows, devoid of the box-like architectural compartments of the previous century. The level of detail

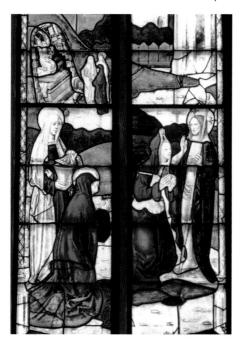

Above left: The three Marys before Christ following His resurrection, installed in around 1510 as part of the extensive Flemish-led glazing of St Mary's, Fairford, Gloucestershire. The figure in contemporary costume nearest Christ is thought to commemorate either the wife of the donor or a daughter of Henry VII.

Above right: Two figures of St Sebastian illustrating late medieval reuse of cartoons. The first is in the clerestorey at St Mary's, Fairford, the second is at Lighthorne, Warwickshire, and clearly made from the same cutline (though with repaired legs and now set within a Victorian window).

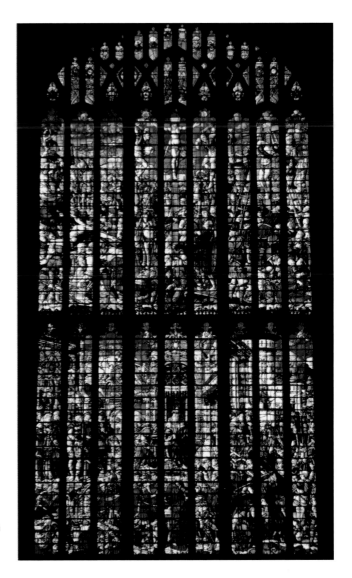

Christ's Passion graphically
recounted in full-blown
Renaissance style in around
1535 by Flemish artists based
in Southwark (either Dierick
Vellert or Galyon Hone) from
the east window of King's
College Chapel, Cambridge.

is astonishing, including some wonderfully imaginative touches in the depiction of the Last
Judgement (with exotic devils and a glass-maker's furnace among the perils of Hell). To what
extent such designs existed elsewhere is impossible to say, though there is evidence that
some cartoons were reused, both here and at Lighthorne, Warwickshire.

While less complete work in a more consciously Renaissance style has survived elsewhere,
the great royal commissions the Flemish artists undertook are sadly mostly lost to us (including
the glazing of Henry VII's chapel, Westminster Abbey). The major exception is King's College
Chapel in Cambridge, with a set of vast, soaring windows dating from 1515–46, the work of
a number of artists, begun under Flower but mostly led by Galyon Hone. There has been a
marked stylistic shift since Fairford, and despite the superlative Perpendicular architecture
that frames them, these windows are wholly Renaissance in spirit.

Did you know?

Fairford and King's College Chapel are the only churches in Britain to retain their complete pre-Reformation glazing, though the latter embraces the Renaissance to such an extent that Fairford is generally considered the one truly medieval scheme to survive (in a parish church at least).

The iconography largely follows the medieval system of pairing New Testament subjects with Old Testament parallels, but here the subjects are enlarged to monumental proportions, with designs crossing mullions and naturalistic landscapes or Renaissance architectural backdrops taking the place of the Gothic canopies of previous generations. The result is a sumptuous, immersive display of colour, populated by richly attired and vigorously drawn figures in animated poses, quite unlike anything ever before seen on these shores. Alas, this new beginning would also prove to be an end.

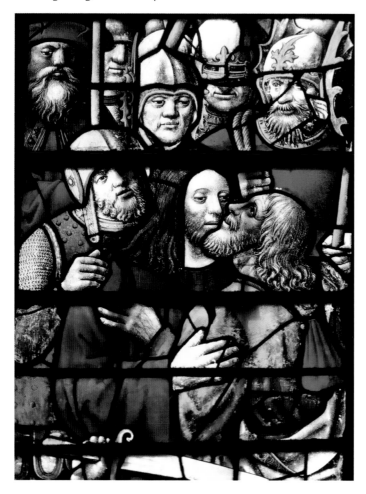

Christ's betrayal, the kiss of Judas portrayed, from a detail of one of the earlier windows (c. 1517) executed at King's College Chapel, Cambridge, by artists who previously worked at Fairford.

4
An Age of Near Extinction

Reformation

The art of glass-painting in Britain comes to an abrupt halt with Henry VIII's break with the Catholic Church in 1534, subsequently unleashing waves of destruction upon our medieval heritage, firstly in the Dissolution of the Monasteries (1536–40) with the Crown's systematic plundering and near wholesale demolition of numerous great monastic churches across the land. The second wave was the iconoclasm of the Protestant reformers; initially, only images of St Thomas Becket were forbidden under Henry (symbols of ecclesiastical resistance to royal dictat), but under his son Edward VI the purges went much further, his short reign (1547–53) witnessing all churches suffer severe losses with art in all media destroyed, under the charges that iconography was 'superstitious and idolatrous'. While it is true that many sculpted and painted images had been venerated to some degree (as devotional aids, rather than substitute divinities), stained glass was considered more didactic or decorative than devotional, but vast amounts were destroyed regardless

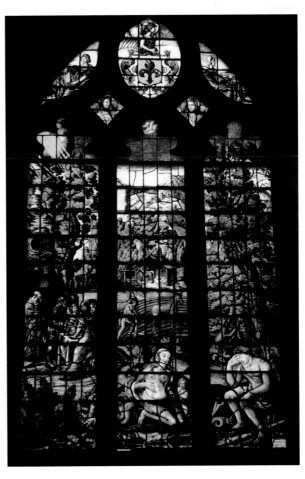

'Paradise Lost': Adam and Eve following their expulsion from Eden. This enamelled window was painted in 1641 by Abraham van Linge, but not installed until 1666 owing to the religious turbulence of the Civil War period. University College Chapel, Oxford.

to eradicate the saintly images they portrayed. However, unlike the destruction of portable items and furnishings (or wall-paintings that could be whitewashed over), destroyed windows necessitated costly replacements in plain glass, thus the decree against imagery in windows was later relaxed.

Windows devoid of colour: a fitting commentary on post-Reformation England. These figures of saints and ecclesiastics by Richard Greenbury were painted during a period of tolerance in 1632, Magdalen College Chapel, Oxford.

Aside from mass destruction of existing artworks, glass-artists were simultaneously made largely redundant. No new commissions for churches could be forthcoming amid such religious turmoil, except for plain-glazing or secular heraldic pieces. The climate was a hostile one for glass-painters, and the craft was virtually extinguished for nearly a century.

A Brief Resurgence

The reign of Charles I saw a thaw in attitudes towards glass imagery, with new windows commissioned for churches for the first time since the Reformation. Provincial pieces survive that are more a less a continuation of medieval design at Abbey Dore and Sellack (Herefordshire). However, the major commissions were to be found in London and particularly Oxford, where the University took a more tolerant attitude and much remains to this day. Several Oxford colleges employed the services of German brothers Bernard (d. c. 1644) and Abraham van Linge (d. c. 1641) who, between 1622 and 1642, embellished many of the chapels with vibrant work in a remarkably painterly style, full of rich detail.

An interesting contrast can be seen at Magdalen College Chapel, where a sequence of windows by Richard Greenbury (installed 1632) was painted entirely in monochrome, with figures more reminiscent of book illustrations in glass. By this period colour was increasingly painted on with enamel, rather than using separately coloured glass, and latterly windows

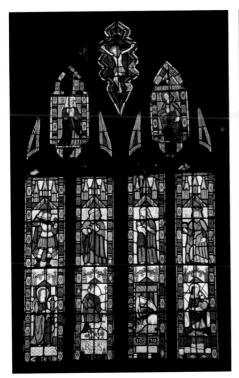

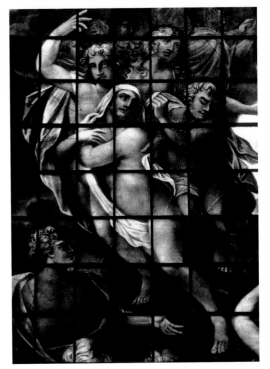

Above left: Provincial glass from the 1630s in Herefordshire featuring naive drawing more akin to folk art, but otherwise a continuation of the medieval spirit, in an example of Gothic Survival. East window at St Tysilio, Sellack, Herefordshire.

Above right: Beautifully detailed background from a window by Abraham van Linge (painted 1641) showing how leadwork no longer follows the design but divides the window into rectangular panes treated as small canvases. University College Chapel, Oxford.

Right: A detail of Richard Greenbury's dramatic Last Judgement, executed in 1632 entirely in monochrome for the west window of Magdalen College Chapel, Oxford.

would be painted entirely on clear, treating the glass like a canvas, with the result that leadwork was no longer required to serve as a graphic element and was relegated to the role of a merely structural grid.

This brief flowering was sadly nipped in the bud by the outbreak of civil war in 1642, the second major calamity to affect our heritage in glass. The brief return of painted imagery had only served to inflame Puritan passions further and a new wave of iconoclasm swept churches across the land, with far more glass lost than during the Reformation. Harrowing accounts exist of the ransacking of cathedrals by Parliamentarian soldiers and the great swathes of glass destroyed by them, one mentioning Cromwell himself ascending a ladder to punch out the last remaining vestiges at Peterborough after the thorough mauling his troops had administered there.

Did you know?

York Minster and the city churches escaped Civil War devastation owing to the terms of York's surrender in 1644 to Parliament's forces under Lord Fairfax, requesting that churches be left unharmed. Fairfax, being a Yorkshireman, was sympathetic and ensured his troops refrained from iconoclasm, thus the city today holds the largest concentration of medieval glass in Britain, believed to be roughly half of our surviving total amount.

The bitter legacy of the years of civil war and the Commonwealth is the most thorough depletion yet seen of stained glass across the country. Instances of glass being removed to safety to escape Puritan zealotry account for the survival of many important works, but the losses are beyond imagining. Tragically, the destruction was such that barely any medieval glass at all survives in Scotland and Ireland.

Baroque and Beyond

The Restoration of the monarchy in 1660 did not herald a return to fortune for glass-painters since the prevailing Baroque style demanded clear glazing to maximise light (even in Catholic Europe). None of Sir Christopher Wren's London churches was designed with coloured glass in mind, and attempts to add such windows since go against the architect's intentions.

Nevertheless there were still notable exceptions, such as the York-based glass painters Henry Gyles (1645–1709) and later William Peckitt (1731–96), who helped keep the medium alive with their skilful exercises in enamel painting. In London three generations of one family dominate the medium at this time, William Price the Elder (d. 1722) being employed for further figurative windows at Oxford colleges. His son Joshua Price (also d. 1722) is best known for his superb set of windows now at St Michael's, Great Witley (Worcestershire). This remarkable set adorns the richest Baroque interior in Britain, a magnificent synthesis of architecture and painted glass from an age that largely rejected the medium. Based on designs by Francesco Sleter and painted in 1719–21, the ten windows read as great canvases in glass, though a significant amount of coloured glass is used in addition to enamel paint on clear panes. Originally made for the chapel of Cannons House (Middlesex), the scheme was transferred en masse to Great Witley in 1747 with only minor adaptations by the artist's

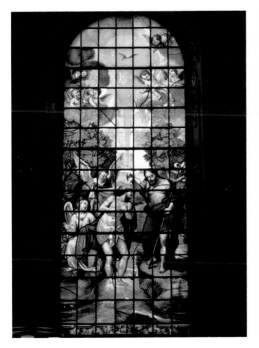

Above left: Baptism of Christ, 1719, painted by Joshua Price to the designs of Francesco Sleter, St Michael, Great Witley, Worcestershire.
Above right: 'Annunciation' painted by Joshua Price (original design by Francesco Sleter), 1719. St Michael, Great Witley, Worcestershire.

son William Price the Younger (1703–65), another extremely proficient painter of enamelled glass. Both father and son also produced major windows for Westminster Abbey.

Otherwise, the Georgian period was an extremely bleak time for stained glass, with prevailing taste indifferent to the medieval past and further ancient work lost through neglect or even deliberately ejected (as under architect James Wyatt, who in 1789 ordered the removal of cartloads of painted glass from Salisbury Cathedral to be dumped in a ditch!). The work of Francis Eginton (1737–1805) stands out as the finest of the age, beautifully finished exercises in enamel painting (on thin panes of clear glass) usually based on designs by other artists such as Benjamin West, who designed his east window for St Paul's Church in Eginton's native Birmingham. His work has, alas, often fallen victim to later changes in taste, some windows being removed or lost altogether (such as his short-lived east window at Lichfield Cathedral, removed after barely a decade).

In contrast to earlier indifference, a growing appreciation of ancient glass around the turn of the nineteenth century influenced taste and saw an influx of glass from the Continent, much being available following the turmoil of the French Revolution. Whole schemes of windows were bought by English travellers, the largest being the vast sixteenth-century Flemish windows of Lichfield Cathedral's Lady Chapel, originally from the abbey of Herkenrode (Belgium). Early French pieces can be seen at Rivenhall (Essex), Twycross (Leicestershire), and Wilton (Wiltshire), while more easily collected Flemish and German roundels can be seen in numerous churches and stately homes throughout the land.

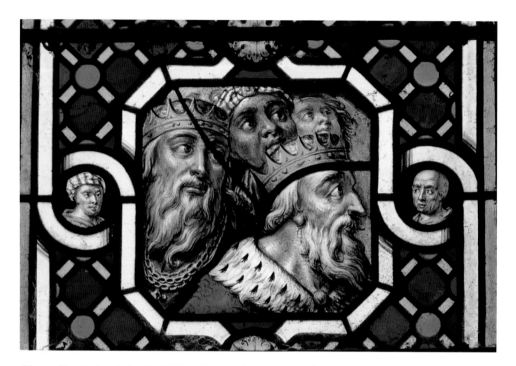

Above: Detail of a window by William Price the Younger, one of many portrait vignettes included in his windows from the 1750s at St Mary's, Preston-on-Stour, Warwickshire.
Below left: The Conversion of St Paul by Francis Eginton, 1791, based on a painting by Benjamin West. East window of St Paul's Church, Birmingham.
Below right: 'Faith' by Francis Eginton, 1795, based on a much earlier painting by Guido Reni (the subject was changed from Mary to Faith personified to avoid enflaming Protestant passions). East window, St Alkmund, Shrewsbury.

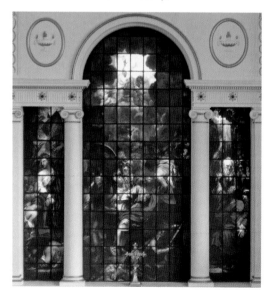

5
Gothic Revival and Mass Production

The early nineteenth century saw the first serious attempts at recapturing medieval techniques of glass painting, most notably in the work of John Betton (1765–1849) and David Evans (1793–1861) of Shrewsbury, whose 1821 repairs at Winchester College Chapel carefully copied fifteenth-century work (alas, in an act of restoration, which saw the glass replaced wholesale rather than restored, a common practice before modern conservation techniques became available. Some original glass has since returned for comparison). Many of their new commissions followed old master paintings, though their series of bespoke figures painted for Lichfield Cathedral in 1819 shows remarkable vigour; the style is notably late Georgian but the amount of coloured glass indicates movement away from enamel as the sole source of colour. The colours then available, however, were limited and somewhat garish, while the enamelled technique was perceived as old fashioned.

Thomas Willement (1786–1871) is usually credited with being the first to return to the traditional form of painted and leaded glass, receiving many largely heraldic commissions but also figurative work in a Neo-Gothic style, beginning a resurgence on an unprecedented scale. By 1830 the Gothic Revival had long taken hold, and demand for new windows in a quasi-medieval idiom was soaring, so much so that in future entire workforces would be necessary.

King Solomon from a sequence by Betton & Evans (to designs by John James Halls), installed in 1819 at Lichfield Cathedral. The window was removed in around 1890 and while much was relocated within the cathedral, this and other figures currently remain in storage.

The Age of Victorian Firms

The first of the major studios emerge at this time: Ward & Hughes (established originally as Ward & Nixon in 1836) and William Wailes (1808–81), who from 1838 produced hundreds

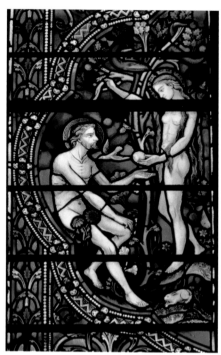

Above left: The Conversion of St Paul by Ward & Hughes, from around 1866: Victorian Neo Gothic at its most dramatic (and least convincingly medieval), north aisle, Lincoln Cathedral.
Above right: Adam and Eve, detail of the west window of Worcester Cathedral by Hardmans Studios, designed by John Hardman Powell (with contributions from architect George Gilbert Scott), 1874.

of Neo-Gothic windows across the country from his Newcastle studio, which was one of the first and most prolific of the Victorian era, at its height employing up to seventy-six craftsmen. It must be added that Wailes's colouring tended to be rather lurid, despite efforts to appear 'medieval'. Leading Gothic Revival architect A. W. N. Pugin (1812–52) initially employed Wailes to translate his own designs into glass but, being dissatisfied with Wailes's results, encouraged his friend, Birmingham-based metalworker John Hardman (1812–67), to set up his own stained glass studio, through which Pugin was able to assert a greater degree of control. From 1845 to well beyond Pugin's death, the studio continued to produce windows in a crisp, linear style closer to Pugin's neo-medieval vision.

Did you know?

Pugin and Hardman's Catholic faith led to Hardman Studios becoming the premier choice among co-religionist clients for decades to come, with an astonishing legacy throughout many of the newly built Catholic churches across the country (following Emancipation in 1829), in addition to an already respectable tally in Anglican churches. The studio was to become the longest surviving of the Victorian period, continuing in some form until 2008.

Perhaps the most prolific of all Victorian firms was London-based Clayton & Bell, formed by the partnership of John Richard Clayton (1827–1913) and Alfred Bell (1832–95). From 1855 the studio produced countless windows for cathedrals and churches, and worked with many of the leading architects of the day, notably J. L. Pearson, who employed them in glazing his newly built Truro Cathedral in its entirety. Their earliest work is their strongest, neo-medieval in style and enlivened by a rich palette and delicate drawing. After 1861 their work became heavier and more sombre in tone, losing the vitality of their early designs. Initially, manufacture had been shared with associates who shared the same premises but who left to found their own fully fledged firms – Heaton, Butler & Bayne and Lavers, Barraud & Westlake, both established in 1862 and enduring studios in their own right.

Thousands of windows mass-produced in varying (but rarely successful) interpretations of early medieval style in a mere few decades left donors seeking alternatives, with tastes inclining more towards later, more florid manifestations of Gothic art. In 1866 Charles Eamer

A Nativity window, an early, more richly coloured work by Clayton Bell from 1861, St Mary, Lapworth, Warwickshire.

St Edmund the Martyr: detail of a window by Charles Eamer Kempe, illustrating his love of delicately painted detail and extensive use of silver-stain on white glass, north aisle, Lichfield Cathedral, Staffordshire.

Kempe (1837–1907) opened his London studio, which became one of the most successful of the century, at its height employing up to fifty people. Kempe's style was a marked departure from his contemporaries, evoking the richly painted and stained windows of the fifteenth century yet in a style immediately recognisable as his own. Characterised by a large proportion of white glass, delicate brushwork and a wheatsheaf signature, Kempe's windows are often as much about detail as colour, but nevertheless are among the most beautifully made of windows, distributed widely until the firm's closure in 1934. The firm of Burlison & Grylls (established 1868) appealed to similar tastes, producing work more directly influenced by Flemish old masters of the Northern Renaissance. Both studios were widely used by architects, particularly G. F. Bodley.

Much of the glass used throughout the Victorian age was produced in London at the long established glassworks of James Powell's & Sons (latterly Whitefriars), who by the 1850s had expanded the range of colours available dramatically. Powell's also had a prolific stained glass studio, though their tendency to use a variety of designers makes their earlier work less consistent in style. Certain artists who saw their first windows made at Powell's went on to great achievements in the medium.

6
A New Flowering

The mass production of stained glass throughout Victoria's reign created thousands of new windows but relatively few that could be classed as great works of art. Most firms were content to manufacture according to tried and tested formulas, regardless of whether the setting was ancient or newly built; those who cared for our medieval heritage grew concerned that so much industrially produced work was unworthy of such edifices. The reaction against this mechanical approach to ecclesiastical glass would bequeath us some of the finest windows ever created in the medium.

The Pre-Raphaelite Reaction

Spearheading the reaction against industrial production was William Morris (1834–96) whose mission was to found a company aiming to restore the role of aesthetics and craftsmanship in response to mass industrial production. Morris & Co. was founded in 1861 (initially as Morris, Marshall & Faulkner till 1875). Morris was influenced by the work of the Pre-Raphaelite brotherhood, whose work attempted to recapture the romance of the medieval spirit without slavishly copying as others had attempted (and so often failed at), drawing their inspiration from 'pure' early Renaissance art ('before Raphael'). Stained glass designers for Morris initially included such artists as Dante Gabriel Rossetti and even Morris himself, but ultimately the role was dominated by Morris's closest friend, Edward Burne-Jones (1833–98), one of the most celebrated artists ever to work in glass.

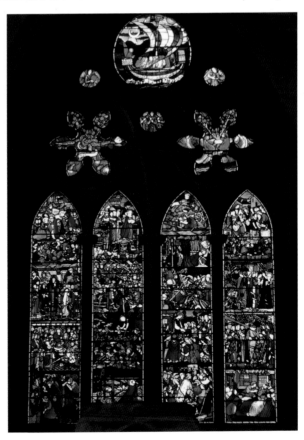

The St Frideswide window, one of the earliest works in glass designed by Sir Edward Burne-Jones and made by James Powell's & Sons in 1859. East window of the Latin Chapel, Christ Church Cathedral, Oxford.

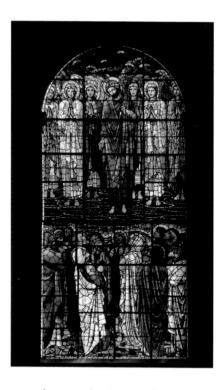

The Ascension, 1885, first of a set of four windows designed by Edward Burne-Jones (for the church he was baptised in) and made by Morris & Co. for St Philip's Church, now Birmingham Cathedral.

His earliest designs for glass were for Powell's (1859–61), in a style very close to Rossetti's, but with Morris & Co. his work developed into the trademark grace and serenity seen in his paintings, with ethereally beautiful angelic figures rendered in exquisitely rich colours, his finest achievement being the set of four windows for Birmingham Cathedral installed in the 1880s. Significantly, late Victorian glass had truly blossomed by suppressing its revivalist instinct, when it finally stopped trying to imitate bygone ages.

Burne-Jones's influence was such that by the end of the century others imitated his style, most notably Henry Holiday (1839–1927), following as designer for Powell's until setting up his own studio in 1890. However, while echoing aspects of the Burne-Jones aesthetic, Holiday's work is strong enough to stand on its own, his compositions full of fluid movement and beautifully coloured. Powell's themselves employed another acolyte as designer in J. W. Brown (1842–1928), whose work bears some comparison in drawing but contrastingly with very restrained colouring.

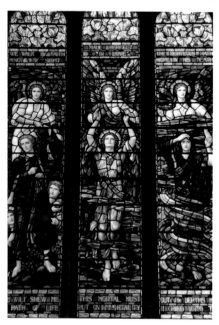

Window by Henry Holiday from around 1918, a swirling composition full of movement, at St Editha, Tamworth, Staffordshire (an earlier version of the same design exists at Chelmsford Cathedral).

Arts & Crafts

The Arts & Crafts Movement was a further step towards reclaiming the decorative arts from commercial mass production, and while Morris is generally regarded as one of its leading inspirations, glass artists of the movement sought an even greater control of the medium as independent makers free of the production line approach (which even Morris had used, Burne-Jones's cartoons having been translated by studio craftsmen).

Christopher Whall (1849–1924) was the movement's leading light, taking the view that the artist's vision would be degraded unless every facet of the process was his own work. Self-taught, Whall worked independently from the 1890s onwards, producing densely painterly work, heavily matted and stippled on richly textured handmade 'slab' glass, both of which were to become defining characteristics of Arts & Crafts glass.

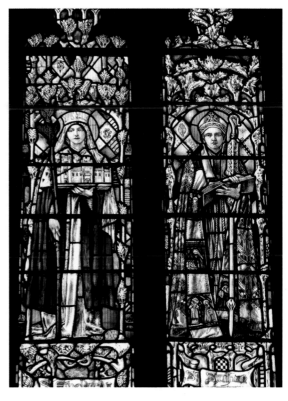

St Etheldreda and St Swithun, two of the many figures executed by Christopher Whall in 1901–2 for his vast scheme in the Lady Chapel of Gloucester Cathedral.

Did you know?

The preferred glass of the Arts & Crafts Movement was mould-blown 'Norman Slab', a new technique developed at the time and rarely used since. Blown into a rectangular mould, the resulting 'bottle' was then cut, its sides forming small, chunky sheets. The material was often very thick, holding the light beautifully, but challenging to cut and lead!

Whall benefitted from use of the premises of Mary Lowndes (1856–1929) and Alfred Drury in Fulham, where they collectively founded The Glass House in 1906 as a launchpad for independent stained glass artists. Whall effectively trained a whole generation of artists in the early twentieth century, many of whom also operated from the Glass House and became stellar talents in their own right, some of the most significant being Louis Davis (1860–1941) and Karl Parsons (1884–1934), who excelled at creating richly coloured work of a radiant, almost shimmering brilliance. Women artists were at last receiving recognition in the medium, with Lowndes and Whall's daughter Veronica (1887–1967) among the first receiving major commissions.

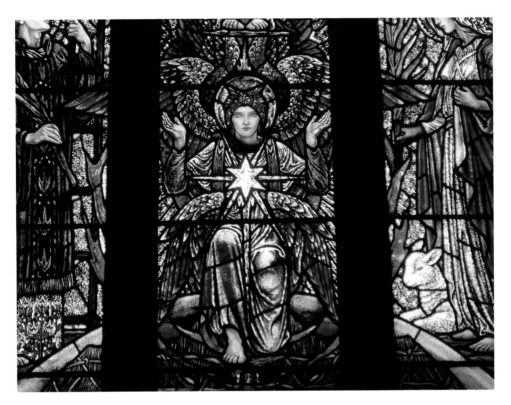

Angel of the Star of Bethlehem: detail of the dazzling 1930 west window by Karl Parsons at St Laurence, Ansley, Warwickshire.

A parallel arrangement in Ireland also launched the careers of some of the greatest artists ever to work in the medium. Founded in 1903, An Tur Gloine ('Tower of Glass') hosted many remarkable talents, none more so than Harry Clarke (1889–1931), whose graphic, stylised figures are embroidered in some of the richest technical effects conceivable in the material. A superb colourist, Clarke was also a fine illustrator, which shows in his rich attention to detail, his hallmark style immediately recognisable. Wilhelmina Geddes (1887–1955) worked in a very different vein, her brooding, muscular figures, broadly painted and usually rendered in more earthy tones, have a monumental quality quite unlike anything seen before. The Irish artists, alas, received fewer commissions in Britain, but their brilliance is manifest in those few places lucky enough to feature their work.

In the Midlands an important group of artists working in a highly illustrative manner were taught by Henry Payne (1868–1940) at Birmingham School of Art. Foremost among them were Archibald J. Davies (1877–1953), Margaret Agnes Rope (1882–1953) and Florence Camm (1874–1960), who collectively produced some of the most beautifully painted, richly detailed work ever seen in glass. Other notable Arts & Crafts artists active in the Midlands were Richard Stubington (1885–1966) and Theodora Salusbury (1875–1956). Many fine artists flourished in Scotland at this time, the foremost being Douglas Strachan (1875–1950), who interpreted Arts & Crafts style with a more modernist vibrancy and dynamic sense of movement.

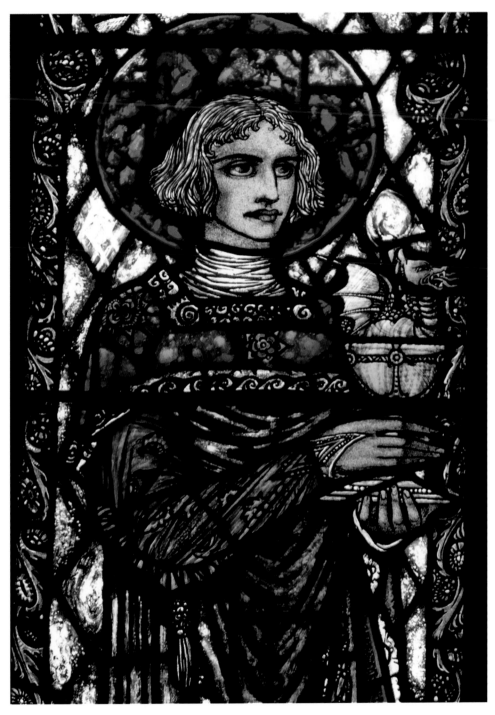

St John the Evangelist holding the poisoned chalice: detail of a late window by Irish artistic genius Harry Clarke from 1929, All Saints, Bedworth, Warwickshire.

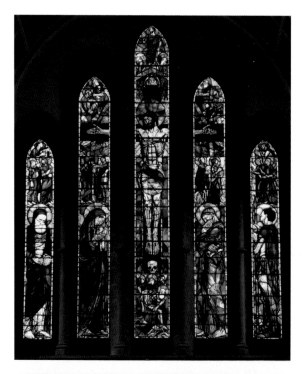

Left: Crucifixion by Wilhelmina Geddes, installed in 1922 at St Luke's Church, Wallsend, Tyne & Wear. Geddes considered this dramatic piece to be her finest achievement.
Below: A scene from the Life of St Kenelm: a detail from Florence Camm's 1915 window dedicated to the saint, beautifully demonstrating her richly illustrative style and draughtsmanship. St Kenelm, Romsley, Worcestershire.

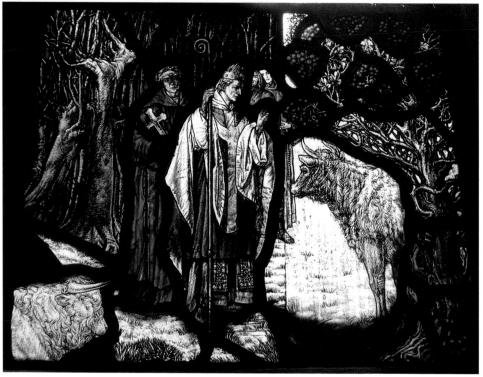

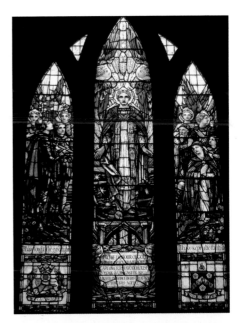

Right: A window by Theodora Salusbury from around 1923: a dramatic composition showcasing her rich sense of vibrant colour and brushwork. St Mary, Queniborough, Leicestershire.
Below: A window by Douglas Strachan from around 1930, illustrating his flair for tense, restless composition combined with a strong sense of colour. Westminster College Chapel, Cambridge.

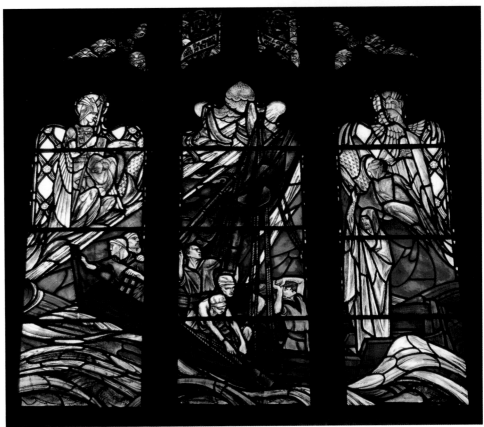

It should be added, however, that the mainstream was not represented by the great talents listed above, with the bulk of windows installed in the early twentieth century still the output of major Victorian firms (albeit with revised styles and newer designers), and mass production still dominated the field. A surge of commissions for memorial windows fed the market following the First World War, but once demand dwindled in the following decades, so did many of the large firms.

After decades of saturated colour and paint, the interwar years saw a lighter alternative become the prevailing aesthetic. Initially, this was in a medievalist idiom (dominated by white glass and stain) such as in the work of Ninian Comper (1864–1960) and Geoffrey Webb (1879–1954), but increasingly more delicate compositions on clear backgrounds prevailed, such as those of Webb's brother Christopher (1886–1966). Hugh Easton (1906–65) often combined a clear ground with bright colouring and a distinctive personal figurative style, if somewhat akin to contemporary graphic art. Most of these artists continued to operate well into the post-war years.

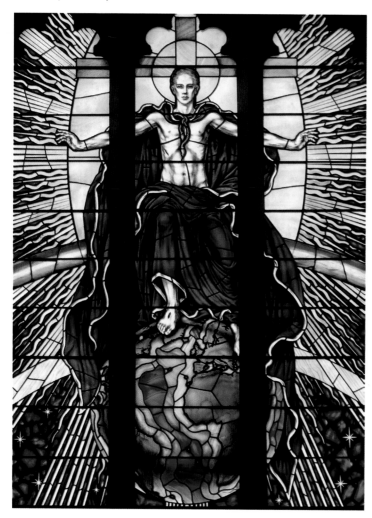

Christ in Majesty as visualised by Hugh Easton in his 1955 west window at Holy Trinity, Coventry.

7
Modern Experimentation

The end of the Second World War marked a new beginning as the recovering country sought new forms of expression to replace what had been lost. Fortunately, older windows had mostly been dismantled and moved to safety and thus survived unscathed, but a large amount of Victorian glass was lost, particularly in cities. The loss of dark, mass-produced windows, however, was regretted by few and opened up new opportunities for contemporary glaziers.

Until now Britain had seen little evidence of developments in contemporary art abroad, remaining somewhat insular and nostalgic while Europe sought new ways forward in expression. Abstract glass had appeared as early as 1915 at St Mary's, Slough (by Polish-Jewish artist Alfred Wolmark), but remained an isolated case until the postwar period. Some of the first expressions in a truly modern idiom came from another major Irish artist, Evie Hone (1894-1955), whose freely rendered figurative compositions in bold colours show clear awareness of developments in art abroad. Her largest project was re-glazing the war-damaged east window of Eton College Chapel in 1952, a truly monumental work. Another European

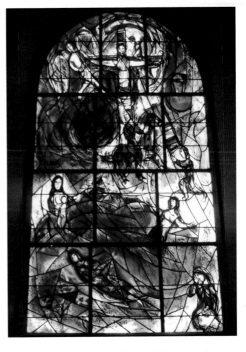

A window designed by Marc Chagall and made by Charles Marq of Reims, the first of an entire scheme, installed in 1967 at the small church of All Saints, Tudeley, Kent. Chagall's only other commission in Britain can be seen at Chichester Cathedral.

who made his impact felt was Erwin Bossanyi (1891–1975), a Hungarian-Jewish refugee whose work echoes the folk art of his native land with extraordinary vibrancy, most notably in his four windows for Canterbury Cathedral installed in 1960 (also to repair war damage). Most famous of all was artist Marc Chagall (1887–1985), whose lyrical scheme at Tudeley (Kent) is a delight to behold.

The first native commission to embrace the modernist spirit was installed in 1956 at Oundle School Chapel, where nine boldly coloured, semi-abstracted figures of Christ formed the first of many designer-maker collaborations between artist John Piper (1903–92) and glass painter Patrick Reyntiens (b. 1925). Their contribution to the medium was to be the defining expression of modern British glass through the latter half of the twentieth century. Piper's rich exercises in pure colour liberated the medium from the heavily pictorial approach insisted on

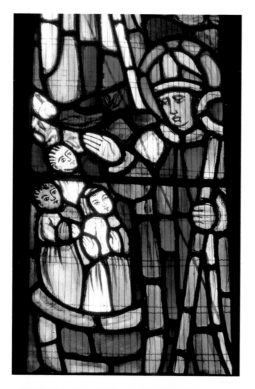

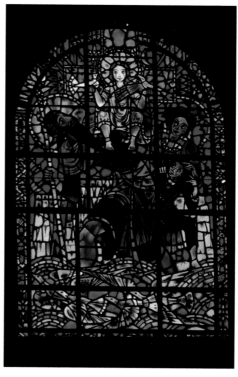

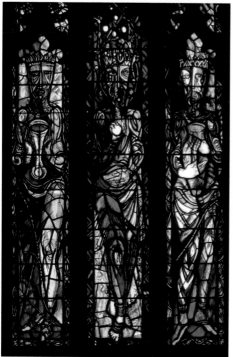

Above left: St Nicholas, part of a window dedicated to the saint by Evie Hone at the former church of Holy Trinity, Ettington Park, Warwickshire.

Above right: St Christopher carries Christ, one of four windows by Ervin Bossanyi installed in 1960 to replace war-damaged glass at Canterbury Cathedral, Kent.

Left: Three aspects of Christ, designed by John Piper and made by Patrick Reyntiens in 1956, a landmark commission for the east windows of Oundle School Chapel, Northamptonshire.

previously. His compositions were usually created as paper-collages, translated into glass by Reyntiens with free, vigorous brushwork. Their most celebrated work is the baptistery window of Coventry Cathedral, a stunning symphony of pure colour orchestrated in 1962.

The rebuilding of Coventry Cathedral was a watershed in British ecclesiastical art, and especially important for the sheer abundance of modern glass it contains. The soaring nave windows were entrusted to a team of three artists from the Royal College of Art, led by Lawrence Lee (1909–2011) and his students Geoffrey Clarke (1924–2014) and Keith New (1925–2012) and combine symbolic elements in mainly abstract form in a progression of primary colours through the cathedral. Lee accumulated an impressive oeuvre elsewhere, largely a contemporary interpretation of the figurative tradition, while New created purely abstract works in a number of ecclesiastical and secular commissions.

The Baptistry Window at Coventry Cathedral, completed 1962, a masterpiece by John Piper and Patrick Reyntiens and perhaps the largest window commissioned for an English cathedral since the Middle Ages.

The dalle de verre technique of setting thick chunks of slab-glass in a concrete or resin matrix enjoyed a brief popularity in Britain during the 1960s and 1970s, most extensively at the new Metropolitan Cathedral in Liverpool, where in 1967 Piper and Reyntiens created a rich display of emanating light and colour for the central lantern tower. The process lent itself best to abstract forms of expression in pure colour and this was exploited to the full, some churches of the period displaying fine examples made by the monks of Buckfast.

The figurative tradition lived on regardless, albeit in more boldly contemporary, stylised form. York artists Harry Stammers (1902–69) and his follower Harry Harvey (1922–2011) worked in a distinctly angular style enriched with flat areas of strong colour. Leonard Evetts (1909–97) chose a similar stylisation in a more muted palette, while John Hayward (1929–2007) developed a more graceful and uniquely personal vision, combining linear, angular forms with rich yet subtle colouring and graphic use of leadwork. Others inclined more to abstract expression: Alan Younger (1933–2004) merged pictorial and abstracted form so effectively that images disappear into an explosion of painterly colours; Mark Angus (b. 1949) harnesses the power of pure colour itself in freely drawn, largely symbolic compositions.

The seeds of a new generation of artists, however, were being sown in Wales at Swansea College of Art, where since 1935 stained glass had been taught under the guidance of designer Howard Martin (1907–72). His successor, Tim Lewis, introduced students to contemporary developments in Europe, especially Germany, the vanguard of modern design, encouraging

Left: Angelic figures by Lawrence Lee: the topmost section of one of the 'red windows' he designed for the nave of the new Coventry Cathedral, installed in 1962.
Below: The abstract glass of Keith New, a bold splash of colour that gives focus to the internal space of the 1963 Church of St John the Baptist, Ermine, Lincoln.

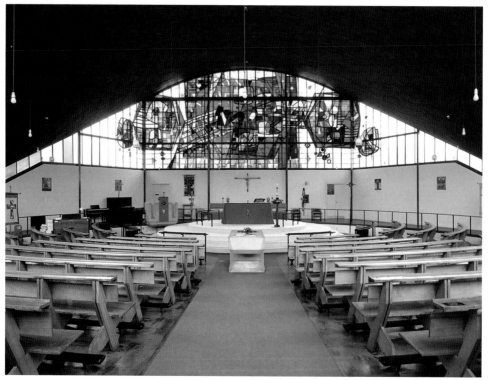

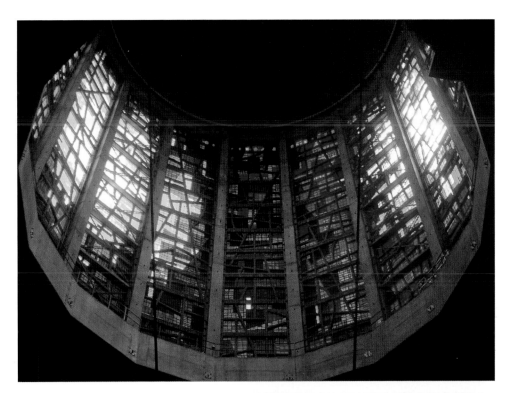

Above: The lantern tower of Liverpool Metropolitan Cathedral, a tour de force in dalle de verre from 1967, created by John Piper and Patrick Reyntiens.
Right: Virgin and Child from a window by John Hayward, installed in 2000 in the north transept of Norwich Cathedral.

Above: Coloured glass ceiling designed by David Pearl in 1989 for the roof of the stairwell of Swansea Observatory (also known as the 'Tower of the Ecliptic').

Below left: Window depicting Christ's Entry to Jerusalem (Palm Sunday) and the Last Supper, boldly reducing the subject to abstracted symbolic elements. Part of a scheme by Mark Angus installed in 2000 at Oundle School Chapel, Northamptonshire.

Below right: Ceiling canopy over the Victoria Quarter in Leeds, designed by Brian Clarke and installed in 1989–90, one of the first of the artist's major commissions enlivening public spaces.

a new generation to embrace the best of contemporary expression in the medium. Many former students have since become huge names in the field, such as Alex Beleschenko, Martin Donlin, Graham Jones, David Pearl and Amber Hiscott.

The late twentieth century has seen a dramatic rise in secular commissions, and it is in this field that the above listed artists have become most established, often eschewing the leaded technique altogether to explore new techniques and possibilities. One artist in this field (of global reach) who still uses leaded glass to tremendous effect in his work is Brian Clarke (b. 1953), whose largely geometric forms create grid-like splashes of colour, frequently forming dramatic glass ceilings in public spaces such as shopping centres and airports.

Into the Twenty-First Century

Do these trends leave leaded work obsolete? Perhaps so in much contemporary architecture, which demands ever increasing expanses of glass and light, yet the aesthetic of the technique has lost none of its appeal and still lives on in ecclesiastical art. It is perhaps too early to say, but church art has struggled to find a voice in the new century, with numerous commemorative Millennium windows often yielding indifferent results (aging congregations can be averse to bold new artistic visions).

There is hope as long as we have artists of great quality, and fortunately this is indeed the case. There are many that deserve mention here but pride of place belongs to Thomas Denny (b. 1956), whose impact has been widely felt in his many major church commissions. Denny's windows

appear at first as rich kaleidoscopes of colour but, drawing the viewer in, reveal a wealth of painted vignettes of incredible detail, a uniquely successful fusion at once both contemporary and traditional. We have also seen an increase in artists outside the medium being invited to design for glass, as we anticipate David Hockney's new window for Westminster Abbey.

The path ahead will be an interesting journey, let us hope that those with the means to commission such works will choose the heritage of the future wisely.

Mary flanked by St Ebbe and St Hilda, installed in 2018, an astonishing work by Thomas Denny, showing his bold sense of colour and incredible love of detail. A work that reveals and rewards on further contemplation. St Peter's, Wallsend, Tyne & Wear.

8
What Now?

This brief introduction can only scratch the surface of the vast wealth of material out there. For further exploration there is much to recommend:

Further Reading

Brown, Sarah: *Stained Glass at York Minster* (Scala 1999). A useful introduction to the extensive collection of nationally important medieval glass in this vast cathedral.

Cormack, Peter: *Arts & Crafts Stained Glass* (Yale University Press 2015). A thorough and long overdue appraisal of this movement and its superb creations.

Cowen, Painton: *A Guide to Stained Glass in Britain* (Michael Joseph Ltd 1985). Out of print but well worth seeking out, especially for exploring Britain's glass heritage, county by county.

Crampin, Martin: *Stained Glass from Welsh Churches* (Y Lolfa Cyf 2014). A superbly comprehensive and lavishly illustrated tome, emphasising the importance of the Welsh contribution in glass.

Crewe, Sarah: *Stained Glass in England 1180–1540* (HMSO London 1987). A scholarly exploration of our medieval glass, extensively illustrated (largely in b/w).

Donnelly, Michael: *Scotland's Stained Glass: Making the Colours Sing* (Mercat Press 1997). An excellent introduction to Scotland's wonderful glass heritage from the nineteenth and twentieth centuries.

Michael, M. A.: *Stained Glass of Canterbury Cathedral* (Scala 2015). A richly illustrated exploration of some of the most important elements of Canterbury's superb windows.

Moor, Andrew: *Contemporary Stained Glass* (Mitchell Beazley 1994). Essential reading for anyone with an interest in contemporary developments, almost exclusively in the secular sphere.

Reyntiens, Patrick: *The Technique of Stained Glass* (Batsford Ltd 1977). An indispensable guide for anyone wishing to explore the technique for themselves, written by one of its greatest practitioners.

Rosewell, Roger: *Stained Glass* (Shire Books 2012). An excellent and concise introduction to the nation's heritage in glass, beautifully illustrated with the author's photos.

Web Resources

There are several websites of that will reward exploration; these are among the most informative:

The British Society of Master Glass Painters www.bsmgp.org.uk
Foremost a showcase and forum for the work of contemporary artists, many of whom have online folios.

Corpus Vitrearum Medii Aevi, Great Britain www.cvma.ac.uk
An extensive database with records and images, part of the Europe-wide project to record and publish all surviving ancient glass.

Stained Glass Records www.stainedglassrecords.org
Robert Eberhard's extensive site covers many of England's southern counties. Low on images, but high on information.

Stained Glass in Wales www.stainedglass.llgc.org.uk
This site is a joy to explore, and features informative notes on each of the artists and studios represented in the churches of Wales.

Vidimus Newsletter www.vidimus.org
A regular newsletter and source of useful information regarding current conservation projects and exhibitions.

Places to Visit

Museums and Galleries

Owing to the architectural nature of glass and the intricacies of displaying ex situ panels, examples of stained glass in museums and galleries are rare, with Ely remaining the only museum in the UK entirely devoted to the medium.

Birmingham Museum & Art Gallery, Chamberlain Square, Birmingham, West Midlands B3 3DH
Tel: 01213 488038
www.birminghammuseums.org.uk

Burrell Collection, Pollok Country Park, 2060 Pollokshaws Rd, Glasgow G43 1AT
Tel: 01412 872550
www.glasgowlife.org.uk

Ely Stained Glass Museum, The South Triforium, Ely Cathedral, Cambridgeshire CB7 4DL
Tel: 01353 660347
www.stainedglassmuseum.com

Jarrow Hall Bede Museum, Church Bank, Jarrow, Tyne & Wear NE32 3DY
Tel: 01914 241585
www.jarrowhall.org.uk

Victoria & Albert Museum, Cromwell Road, South Kensington, London SW7 2RL
Tel: 02079 422000
www.vam.ac.uk

Churches and Cathedrals

By far the best places to see stained glass in its traditional context are churches and great cathedrals across the country. It is, however, important to be selective if making a special trip, with vast quantities of mass-produced Victorian and later glass outweighing the amount of historic or truly special windows. Equally, many of the more architecturally rewarding buildings may not necessarily have glass to match, while the most insignificant chapel could contain a real gem. Below is a very selective list of some of the most important churches to visit, covering all periods.

King's College Chapel, Cambridge, CB2 1ST
Tel: 01223 331100
www.kings.cam.ac.uk

Canterbury Cathedral, The Precincts, Canterbury, Kent CT1 2EH
Tel: 01227 762862
www.canterbury-cathedral.org

Coventry Cathedral, Priory Street, Coventry, West Midlands CV1 5FB
Tel: 02476 521200
www.coventrycathedral.org.uk

St Mary's Church, High Street, Fairford, Gloucestershire GL7 4AD
Tel: 01285 712611
www.stmaryschurchfairford.org.uk

Gloucester Cathedral, 12 College Green, Gloucester GL1 2LX
Tel: 01452 528095
www.gloucestercathedral.org.uk

Great Malvern Priory, Church Street, Malvern, Worcestershire WR14 2AY
Tel: 01684 561020
www.greatmalvernpriory.org.uk

St Michael's Church, Great Witley, Worcestershire WR6 6JT
Tel: 01886 888379
www.greatwitleychurch.org.uk

Lincoln Cathedral, Minster Yard, Lincoln LN2 1PX
Tel: 01522 561600
www.lincolncathedral.com

Oundle School Chapel, 10 Milton Road, Oundle, Northamptonshire PE8 4AD
Tel: 01832 277160
www.oundleschool.org.uk

Christ Church Cathedral, St Aldate's, Oxford OX1 1DP
Tel: 01865 276150
www.chch.ox.ac.uk

All Saints Church, Tudeley, Tonbridge, Kent TN11 0NZ
Tel: 01892 836653
www.tudeley.org

Wells Cathedral, Cathedral Green, Wells, Somerset BA5 2UE
Tel: 01749 674483
www.wellscathedral.org.uk

York Minster, Deangate, York YO1 7HH
Tel: 01904 557200
www.yorkminster.org